A MODERN PHOTOGUIDE
GETTING STARTED IN PHOTOGRAPHY

by

Les Barry

PRENTICE-HALL
Englewood Cliffs, New Jersey 07632

AMPHOTO
Garden City, New York 11530

CONTENTS

For Leda, David, and Steven

PREFACE

This book is an introduction to both cameras and photography. As an introduction to cameras, the book includes sections on the various types on the market, describes their features, and tells what each can do. It is the author's hope that the reader will, after having read this book, be able to decide which camera most suits his purposes and intentions.

As an introduction to photography, the book is written to provide a series of basic lessons that will help the reader *understand* photography and take good pictures.

By the time he has completed the book, the reader may find that he has mentally bought and sold two or three cameras—the description of one camera type might have had a strong appeal for him, until he read further and discovered some other. But in buying a camera there are several matters that should be taken into consideration. First, of course, might be the financial aspect, but this could be the most misleading. The person who buys the most expensive camera *he can afford* might well be missing one or two down the line that would have features much more able to fulfill his needs, based, of course, on his individual interests. The person who buys the most expensive camera on the market might well be defeating his purpose by either saddling himself with conveniences he'll never use,

making liabilities of them, or buying a camera made for a special type of photography, thereby limiting its use for general snap-shooting. The person who buys the cheapest camera on the market might well find, by shopping around, that very little additional money would be required for the purchase of a camera with enough in the way of additional features to give him twice as much versatility.

How, then, does one decide? He must narrow down his photographic interests and examine them. If it turns out he really has no plans to progress beyond taking an occasional snap for the family album, why not buy the camera that will make this easiest for him? If, though, he thinks he might want to get into photography as a serious hobby, or even a possible profession, he should look for the camera he'll be able to learn best with, but one that will, nonetheless, allow him to take acceptable pictures while learning.

Having accomplished this (and having read the book), one should make a list of all the camera features he finds necessary, then go out and find the camera that comes closest to including them all, while remaining within his price range.

The author is indeed grateful to Charles M. Stern, the artist-photographer who made the drawings that illustrate the chapter openings.

LES BARRY

1

WHAT IS A CAMERA, ANYWAY?

The word *camera* is Italian for *room,* and its use to describe the instrument we use for capturing images goes back at least as far as the fifteenth century, when it was part of the term *camera obscura,* or "darkened room." The darkened room referred to was exactly that—a room from which all light was omitted, except that which came through a small hole in one wall. If the hole was small enough, the light it admitted formed an inverted image which was projected upon the opposite wall. The use of this principle before the invention of photography was, in fact, similar to its use in photography today. It aided artists in capturing images. It was simple enough in operation. The artist would hang a sheet of paper on the wall onto which the image was projected. Then he merely traced it and wound up with a very accurate drawing. During its use as a drawing aid, the *camera obscura* developed to a point of portability, too; first as a tent or sedan chair which could be set up to face any particular view. Then it was discovered that it could be reduced in size even to that of a box, with the wall onto which the image was projected being replaced by a sheet of translucent paper, so the artist could then do his work from outside the camera.

Naturally, the *camera obscura* was refined and developed still further, but the basic principle remained the same, and this basic principle still works for the modern camera. That is, a camera, no matter how simple or complex, is essentially a box with an opening in one wall to admit light which is projected onto the opposite wall, where it is captured. It is captured, in the case of photography, by a light-sensitive film which rests against that opposite wall. This wall or flat surface is known as the *film plane,* or the *focal plane,* since it is the surface on which the projected image is focused.

THE LENS

What about that other wall, the one which admits the light? The original concept, that all that was required was an opening, soon found itself calling for refinement. In order for the incoming light to be inverted and projected with a reasonable amount of clarity of detail, the hole had to be relatively small. This had the corresponding disadvantage of not letting in enough light for comfortable viewing under other than the brightest conditions. So, by the sixteenth century, a glass lens was added to the opening. The glass lens allowed the opening to be many times larger than it had been, because the lens was able to gather the incoming rays of light and project them with clarity onto the focal plane. With the improvement of lens designs came this complication: the multi-element glass lens, depending on its size and shape, projected its sharpest image only to one specific point, and the location of the focal plane had to be adjusted to conform to this (or the reverse, of course, the size and shape of the lens had to be adjusted to suit the location of the focal plane).

In photography, there is a camera which is simpler than the simplest box camera. Known as the *pinhole* camera, this home-made instrument is exactly what the name indicates, a box with a pinhole serving as its

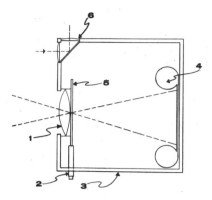

These are the basic parts of a camera: (1) is the lens; (2) is the device for activating the shutter, (5); the lens' field of view is duplicated by that of the viewfinder, (6); (4) is the film-advance mechanism. All are contained in a lighttight box, (3).

lens. In addition, of course, there is some device at the other end for holding the film. The image photographed by the pinhole camera always is sharp, or in focus. However, when we add a lens to this box an entirely different optical process takes place. To understand this, we must understand that a lens is simply one or more pieces of curved glass (or other transparent material) that change the course of the light passing through them. Light, as it travels through the air, moves in a straight line, or for purposes of discussion, moves in light waves, which constitute a series of lines. If a light wave enters a piece of glass at any angle other than 90 degrees, it is bent, or *refracted*. Light entering a curved surface would, naturally, enter in a series of different angles. The lens must bend these light rays so that after they pass through it they will come together at a predetermined point. This predetermined point would be the film plane.

In addition to a lightproof box and a lens, four other parts complete the basic camera. These are the shutter; a device for activating it; a mechanism or provision for changing film without allowing it to be exposed to light; and something which will allow the camera user to determine, in advance, how much of a given subject or scene will be included in the final photograph.

THE SHUTTER

Basically, there are two types of shutters: the leaf-type shutter, which is made up of several blades of metal that come together and overlap in such a manner as to keep all light from passing between them; and the curtain-type shutter, a silk or extremely thin metal curtain in which there is an adjustable slit. The leaf-type shutter is found immediately behind the lens or between two of the glass elements of a multi-element lens. The curtain-type shutter is found immediately before the film plane. When a spring is released, the blades of the leaf-type shutter open for the amount of time required to allow enough light to pass through the lens and reach and affect the film. The curtain-type shutter lies between two rollers, with the section containing the slit wrapped around one of the rollers so that nothing but a lighttight curtain covers the film. When its spring is released the curtain is wound from one roller onto the other, causing the slit to pass across the film at a rate of speed that would permit enough of the light passing through the lens to reach and affect the film. *The film plane is known more commonly as the focal plane, since this is the part of the camera at which the refracted light waves meet, or focus; the curtain-type shutter is called, therefore, a focal-plane shutter.*

That gadget you push to make the shutter open and shut is called a shutter release. The shutter release does not, of itself, move the shutter, as might appear. Shutters are spring-activated; when the shutter is ready for action the spring is stretched out or forced together. The shutter release allows the spring to return to its relaxed position, moving the shutter in the process. In some cameras the spring must be "cocked," manually, before another picture can be taken; in very simple cameras (usually those having only one shutter speed) the cocking and releasing of the spring is done in one operation of the release; in the newer models of the more complex cameras the

cocking of the shutter is combined with the film-changing action, making it an automatic process and at the same time preventing accidental double exposures (which result when the shutter is released more than once without changing the film).

THE FILM ADVANCE

In the beginning of photography, taking a picture was followed by rushing the camera into a darkroom, so that the film could be removed for development. Today's cameras, however, are constructed in such a manner that a number of photographs may be taken before development. Roll film is enclosed in a lightproof material (paper, metal, or plastic), and an entire roll of film (on which from 8 to 36 pictures can be taken) is inserted into the camera. The film is packaged on a spool, and it is rolled from it to another spool inside the camera. Enough film is advanced each time to permit taking one picture. The take-up spool inside the camera is coupled to a knob or trigger on the outside of the camera to permit the film to be advanced without the camera's having to be opened. In some cameras an automatic stop guides the amount of film advanced between exposures. On others, a window is provided. Through this window the camera user can see the numbers printed on the paper that backs up the film, and the film is advanced, after each exposure, until a new number appears at the window.

THE VIEWING SYSTEM

Naturally, anyone taking a picture wants to know, before releasing the shutter, exactly what part of the scene before him will be included in the photograph. All cameras provide for this. With some cameras the user is able to see through the same lens which is taking the picture and see, thereby, just what the film will register; with some cameras a second lens, similar to the taking lens, shows him what the taking lens sees. Other cameras have external frames, which are set to outline the area covered by the lens; while some cameras have glass eyepieces that include the same view as do their accompanying lenses, or that are marked with bright lines to show the view seen by the lenses, plus a little extra to give you an idea of what you might be missing.

In addition to these six basic parts, many cameras provide the user with two controls:

The *shutter-speed* control allows you to choose from a series of "times," mostly fractions of a second, and decide how long the shutter should stay open.

The *lens aperture,* or the size of the opening in the lens through which the light passes, is regulated by an adjustable part called the *iris diaphragm.* This is constructed of a group of overlapping leaves, similar to the leaf shutter, with a relatively circular opening in the center. The opening can be made larger or smaller by turning a dial that changes the position of the leaves.

The very simplest cameras permit neither of these to be adjusted. Aperture and shutter speed are "fixed" to allow photographing a non-moving subject by bright sunlight.

The leaf-type shutter is made up of several blades of metal. They come together and overlap, keeping light from entering the camera; and they open, when activated, for the instant required for the light to pass through the lens to the film.

The curtain-type shutter is operated by spring-activated rollers. When the shutter is released, the opening in the curtain passes in front of the film for the length of time necessary to make the exposure.

2

FOCUSING—ONE WAY TO CLASSIFY CAMERAS

We mentioned previously that the light reflected from the subject travels in straight lines. These are not, however, parallel lines. They radiate outward, somewhat like the spokes of a wheel, with any single point on the subject being the hub of the wheel. The lens must bend these lines so that they will come together again, at a single point. With most cameras, the distance between the lens and the film (the focal plane) must be adjusted in relation to the distance between the camera and the subject to make these lines of light come together at the focal plane. The closer the camera is to the subject, the greater the distance between the lens and the film must be, and vice versa.

When a camera is in focus, there is actually only one two-dimensional plane of the subject which is absolutely sharp on the focal plane. However, some area in front of this plane and some behind it *appears* to the human eye to be sharp as well. This area of sharpness is called *depth of field*. The depth of field in a photograph is also subject to control. It is controlled by two things, the aperture and the distance between the camera and the subject. The smaller the lens aperture, the greater the depth of field. And the farther the camera is from the subject, the greater the depth of field. Therefore, a camera with a particularly small aperture, which is never used to take close-up pictures, would have a great amount of depth of field. Of course, because of its small aperture this camera could not be used to take pictures in any but the brightest daylight conditions. On the other hand, it would not be necessary to focus such a camera if the user did not get too close to the subject. Such a camera exists and is called the box camera.

However, if you want to take pictures under unfavorable (according to box camera terms) lighting conditions, and must, therefore, use a camera whose lens can be opened to let in a large amount of light; or if you want to use a fast shutter speed to stop action, and must compensate by using a large lens aperture, you must have a camera with some focusing control.

There are three basic methods of focusing: measurement, groundglass, and rangefinder.

MEASUREMENT

Cameras which focus by this method do not offer any mechanical aid to focusing, but if properly focused they are just as accurate as the two more complex methods. You must measure, or otherwise know, or guesstimate the distance between the camera and the subject. Then you adjust the distance between the lens and the film. These cameras have footage scales, and when the footage scale is set for the camera-to-subject distance, the lens-to-film distance is automatically set. The most efficient method of determining the distance between the camera and the subject is by actual measurement. If you know the size of your shoe, you can pace out the distance for a fairly accurate measurement. Accuracy is especially important with subjects near the camera. Subjects farther from the camera receive the benefit of the increased depth of field.

GROUNDGLASS

There are three distinct types of groundglass focusing. With each, an image is projected onto a piece of translucent glass, and the lens is moved in and out until this image is sharp.

The *view camera* represents the simplest type of groundglass focusing. However, view cameras are large and have little appeal to the beginner. They are used, ordinarily, by professional photographers and can be found in many portrait studios. View cameras use sheet film, which is inserted into the camera one sheet at a time. The groundglass is on the back of the camera in a spring-mounted frame. When there is no film in the camera, the groundglass occupies the position of the film. Therefore, the image, having entered the lens, is focused on the groundglass instead of the focal plane. Once the camera is in focus the film is inserted in front of the groundglass. Once the film is in the camera it is impossible to focus on the groundglass without removing the film.

The more popular and practical (for the beginner, anyway) groundglass focusing systems are found on the reflex cameras.

The *twin-lens reflex* has, as the name implies, two lenses, one above the other. Only one of these is used for taking the picture. The other is used for focusing. These two lenses are perfectly matched for size and position, and move in and out simultaneously. However, behind the top lens is a mirror which is placed at a 45-degree angle. This mirror reflects the image entering the lens to a groundglass screen above it. Although the direction of the image is changed by the mirror, the distance it travels between the lens and the groundglass is identical to the distance between the bottom (taking) lens and the film plane. Therefore, when the image on the groundglass is in focus, the image that will enter the taking lens (during the period the shutter is open) will be in focus.

The *single-lens reflex* also reflects the image off a mirror, but this mirror is behind the taking (and only) lens. The mirror would, naturally, get in the way of the film,

A telephoto lens makes a picture like this one possible. It allows you to move in close without disturbing your subject.

At the right time of day, natural lighting can enhance a scene by accenting subject elements and creating texture.

but when the shutter release is pressed on a single-lens reflex camera, the mirror is snapped out of the way just a fraction of a second before the shutter opens.

With the twin-lens reflex one of the lenses, the viewing lens, remains completely open at its full aperture, to permit the easiest viewing and focusing. Aperture control exists in the taking lens. In the single-lens reflex, on the other hand, an arrangement must be made to keep the iris diaphragm open during the focusing and viewing, yet close it down to the required aperture during the taking. Several methods of doing so are available.

Automatic. The proper aperture is set on a scale, but the iris diaphragm remains completely open during viewing and focusing. Then, just an instant after the shutter release is pressed, the spring-controlled diaphragm is released and closes to the predetermined aperture.

Preset. The proper aperture is set on a ring on the barrel of the lens. This ring is not connected to the diaphragm, but is merely a stopping device. Just before snapping the picture you flip the aperture-control ring, without taking the camera down from your eye, and the ring is halted at the predetermined aperture by the presetting ring.

Manual. After focusing, you close the diaphragm to the required aperture, return the camera to your eye, view, and shoot.

RANGEFINDER

The rangefinder consists, basically, of two prisms, two front windows, and a rear eyepiece. The two prisms reflect the light to the single eyepiece, and by looking through the eyepiece you will see two images. But by changing the positions of the prisms you can superimpose one image completely over the other.

With cameras that have built-in rangefinders, moving the prisms is accomplished by turning the barrel of the lens (moving the lens in and out), which is coupled to the rangefinder. When the two images are combined, the lens is focused. With separate rangefinders, the prisms are moved by a dial, and when the rangefinder is focused the distance between it and the subject is registered on a footage scale, showing the exact distance between you and the subject. This information is then used to adjust the lens so that the camera is in focus.

3

ABOUT THOSE DIALS

A common complaint among people who want to expand their photographic horizons by switching to better and (granted) more complex cameras goes something like this: "I'd get a better camera, but all those dials make it so much more complicated to take a picture." Actually, nothing could be further from the truth. All those dials really contribute toward making it *easier* to take a picture, because they give you *control*. This is not to suggest that everybody would be better off with the best camera made, only that it's impractical not to be able to take the pictures you *want* because you're frightened by the camera that could make it possible.

There are three basic dials, and they cover the three basic controls we mentioned previously. One operates the iris diaphragm, one controls the speed of the shutter, and one indicates distances between the camera and the subject.

DIAPHRAGM (APERTURE) CONTROL

The one that operates the diaphragm is marked with a series of unfamiliar-looking numbers, which become, quickly enough, a natural part of your knowledge. These are called *f/numbers, f/openings,* or *f/stops.* The *f* is the important thing; it means that the number following it indicates the size of the opening in the iris diaphragm. A lens is often known by an *f/*number, and this simply refers to the maximum amount of light that can enter it when the iris diaphragm is fully open. These numbers are engraved in a series, and each number means the diaphragm is opened to admit twice as much light as was admitted at the previous number, or *f/*stop, though the number is neither half nor double the number preceding it.

The full scale of *f/*stops would go like this: 1, 1.4, 2, 2.8, 4, 5.6, 8, 11, 16, 22, 32, 45, 64

However, it is impossible for one lens to include all these stops. Instead, any one lens would include a series of no more than seven or eight numbers taken from within the scale. For instance, an *f/*2 lens would, normally, run through *f/*16, while an *f/*5.6 lens might stop down as far as *f/*32.

The smaller the number, the larger the diaphragm opening. Therefore, the hypothetical *f/*2 lens would be fully open when the dial is set at *f/*2. However, when the dial is set at *f/*2.8 only half as much light enters the lens as at the previous setting. At *f/*4 half the amount of light that was able to enter at *f/*2.8 would be able to enter the lens; this would be one-fourth the amount that was able to enter when the dial was set at *f/*2.

With some lenses the widest openings might not fall exactly on a full stop. For instance, the amount of light entering a particular lens when its diaphragm is completely open might measure halfway between *f/*2.8 and *f/*4. This lens, then, would begin at an opening called *f/*3.5, and the next opening on its scale might be only half a stop away, or *f/*4. From that point on, however, it will probably pick up the scale and be measured in full stops. (On some lenses the *f/*numbers are engraved in half stops, particularly on older cameras. Although this practice has gone out of style, it remains something to watch out for and to take into consideration when using such a camera.)

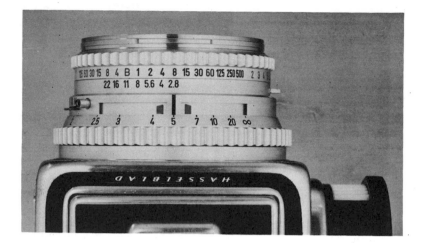

This view of a Hasselblad camera shows the three basic dials and their relation to each other. The top dial indicates shutter speeds. The "1" stands for a full second. The numbers to its right are fractions of a second. The numbers to the left of "B", which means bulb, stand for full seconds. The second dial indicates aperture sizes, with 2.8 being the largest diaphragm opening possible and 22 the smallest. The bottom row indicates the number of feet between the camera and the point of sharpest focus. In this picture the camera is set at ⅛ sec. at an aperture of f/2.8, and is focused on an object 5 feet away.

SHUTTER-SPEED CONTROL

The amount of light striking the film also is controlled by the speed of the shutter. This could present a problem if it weren't for the fact that shutter speeds, like *f/*openings, ordinarily are set so that each speed in the progression is twice (or half) as fast as the one preceding it. Shutter speeds are given in fractions of a second. However, because of the small amount of room for engraving these numbers, and to make the numbers as large as possible, the top half of the fractions is usually omitted. Therefore, a "25" on the shutter-speed scale actually would stand for $\frac{1}{25}$ sec.

Shutter speeds are considered in terms of two scales—slow speeds and fast speeds. The fast speeds are those at which you can take pictures while holding the camera in your hand; the slow speeds are those at which the camera must be supported by a tripod or some other firm object to keep it from moving and blurring the picture.

Fast speeds are calibrated according to two scales, one taking off at $\frac{1}{30}$ sec. and one taking off at $\frac{1}{25}$ sec., although the former is most popular with more recent cameras. The speeds starting with $\frac{1}{30}$ sec. would read this way:

30 60 125 250 500 1000

The speeds starting with $\frac{1}{25}$ sec. would read like this:

25 50 100 250 500 1000

We can see that both wind up with $\frac{1}{1000}$ sec. Actually, the first is more precise than the second in terms of doubling from one setting to the next. But in the higher speeds, the difference between, for instance, $\frac{1}{100}$ sec. and $\frac{1}{125}$ sec. is so slight as to be not worth considering.

There is a bit of variation in the listing of slow speeds, but a typical scale would look pretty much like this:

1 2 4 8 15

With the exception of the number "1" (which stands for a full second), these, too, are fractions. The "2" stands for $\frac{1}{2}$ sec., the "4" stands for $\frac{1}{4}$ sec., and so on. These are

classified as "slow" speeds, because they are speeds at which most people cannot hold a camera steady during the length of an exposure. Even $1/30$ sec. is too slow for many people, and generally speaking, $1/60$ sec. should be considered the slowest hand-held speed for photography by persons without a great deal of experience in holding cameras steady. When using a slower speed, the camera should be supported on a tripod or other stationary surface.

There are two other speeds, one or both of which may be found on shutter-speed dials. They are "T" and "B". "T" stands for time exposure, and when your camera is set for it the shutter will remain open from the time you press the shutter release until you press it again. "B" accomplishes the same thing, except that "B" will keep the shutter open only as long as the shutter release is held down, and will allow it to close when the release is let go. "T" and "B" also require support for the camera.

DISTANCE (FOCUS) CONTROL

The distance scale performs several functions. For cameras which do not provide rangefinder or groundglass focusing, the distance scale is the only sure way of focusing the camera—provided, of course, that you know the distance between the camera and the subject. On the other hand, when focusing is done by rangefinder or groundglass, the distance scale shows the distance between the subject and the camera as it has been determined and set by the focusing device. The distance scales of cameras made to sell in the United States will be calibrated in feet, or fractions thereof. Occasionally, though, you'll run across a camera calibrated in meters, or both.

At one end of the distance scale is a number which shows the closest distance you can focus the camera, or the closest you can bring the camera to the subject and still get the subject in focus. At the other end of the distance scale is a symbol that looks

like this ∞. It is, as you'll notice, a continuous line that goes on and on and on, *ad infinitum,* and this is exactly what it stands for: infinity. When the distance scale is set on infinity everything visible beyond a certain point will be in focus.

The distance scale makes obvious sense on cameras that do not have any other focusing methods, but you might wonder what purpose it serves on cameras with rangefinder or groundglass focusing, since these cameras can be focused without your having any idea of the subject-to-camera distances. It happens that knowing the distance between the camera and the subject can aid you in two other areas: in flash photography, and in making use of depth of field. In flash photography exposure is determined according to the distance between the flash gun and the subject. With automatic electronic flash, however, the need for the photographer to determine and set camera aperture for proper exposure is eliminated.

DEPTH-OF-FIELD CONTROL

Depth of field, as pointed out previously, is that area before and behind the point on which the camera is focused which appears sharp to the human eye. Depth of field is influenced by three things: (1) the focal length of the lens (which we'll talk about in the chapter on accessories); (2) the size of the aperture; and (3) the distance between the camera and the subject. The farther the camera is from the subject, the greater is the depth of field; the smaller the aperture in the iris diaphragm, the greater the depth of field.

You'll notice that next to the distance scale on your camera or lens barrel is a twin scale of *f*/stops identical to those on your diaphragm scale. These scales of *f*/stops begin at one central point (usually sharing the smallest number, *i.e.*, largest opening), and go off in opposite directions. The central point also serves as the indicator for the distance scale. That is, the number on the

distance scale opposite this central marking is the distance between the camera and the subject. If you were going to try to determine your depth of field by using the distance scale, you would first focus the camera. Then you would find, on your depth-of-field scale, the two *f*/stops identical to the one at which your diaphragm has been set. Each of these is opposite some point on the distance scale. One of these points is the nearest limit of your depth of field at that distance and *f*/stop, the other is the farthest. In other words, the area between the two distances indicated on your distance scale is your depth of field.

Now then, suppose you want to change your depth of field. Suppose you want to increase it, to include just a bit more of the background or some object in the foreground; suppose you want to decrease it in order to blur the background. If you want to do this *without changing the position of the camera,* you simply open or close the iris diaphragm to an *f*/stop that will give you the depth of field you have in mind.

But increasing or decreasing your aperture will, of course, alter the amount of light entering the lens, and therefore, change your exposure. You compensate for this by increasing or decreasing the shutter speed. A larger aperture will require a faster shutter; a smaller aperture a slower shutter. Since both the diaphragm scale and the shutter-speed scale are set up to double or halve their effects from one number to the next, you compensate number for number; that is, a one-stop increase in the size of the diaphragm will be offset by a one-number increase in the speed of the shutter.

The same system of compensation works when you find you have to change shutter speeds to suit a particular picture. If your subject requires a fast shutter, you compensate with a large aperture. In selecting shutter speeds you might keep in mind that a hand-held camera should be set for $1/25$ sec. or faster. Also, a moving subject traveling at right angles to the camera requires a faster shutter speed, if it's to be stopped,

than does one moving diagonally toward or away from the camera; and the farther away the moving subject is from the camera, apparent movement is lessened as is the need for high shutter speeds.

EV SYSTEM

A system for making compensations for changes in aperture and shutter speed automatic can be found on many cameras. This is known as the EV, *exposure value,* system. Basically, the EV system locks together the aperture and the shutter-speed scales so that a change in one will result in an automatic and compensating change in the other. A camera equipped with an EV system can be set according to the *f*/stop and shutter-speed dials, or it can be set to an EV number.

EV numbers range from 1 to 18, although some cameras might not include the entire range. Each EV number stands for a set of combinations of *f*/stops and shutter speeds. Each of these combinations will allow the same amount of light to enter the lens and give you what would amount to the same exposure in a given picture, except that there would be a variety of depths of field and action-stopping capabilities, depending on which of the combinations you chose. You must still select from this group of combinations the one most suitable to the picture you are taking. You can't decide that the proper exposure for a scene is, for example, EV 10, set your camera for that number, and shoot, confident that your picture will be all right. Because EV 10 represents all these combinations:

$1/2$	sec. at *f*/22
$1/4$	sec. at *f*/16
$1/8$	sec. at *f*/11
$1/15$	sec. at *f*/8
$1/30$	sec. at *f*/5.6
$1/60$	sec. at *f*/4
$1/125$	sec. at *f*/2.8
$1/250$	sec. at *f*/2

So, if you simply set your camera on EV 10, you might get any one of the above combinations and possibly find yourself taking hand-held pictures at a ½ sec. exposure, or trying for maximum depth of field at f/2—either of which would be unsuccessful. However, if you set your camera for EV 10 and know you want, for instance, the maximum depth of field, you could move your interlocked dials to f/22, knowing that the shutter speed would be adjusted accordingly. But you must check the shutter speed to make sure it's practical for the conditions under which you're shooting. In this case, you know you'll need a tripod or some other support. If none is available and you find you must shoot with the camera hand-held, you'll have to readjust to ¹/₃₀ sec., opening your aperture (automatically) to f/5.6, which would be the smallest aperture available to you under these circumstances and would reduce the depth of field you could use.

DETERMINING PROPER EXPOSURE

We've talked a good bit about accurate exposures and the importance of setting the various dials of the camera to permit just enough light to enter the lens to expose the film properly. How do we determine exactly how to set the diaphragm and shutter to accomplish this?

The most accurate way is to measure the light with an *exposure meter*. There are two basic types of exposure meters. One, the reflected-light meter, contains a photoelectric cell that measures the amount of light reflected from the subject in the direction of the camera. This is translated into shutter speeds and f/stops on a dial, and the user selects the combination of shutter speed and f/stop that most suits him, in much the same manner as he would select from the various combinations made available through use of the EV system. (Many meters incorporate EV numbers.) The sec-

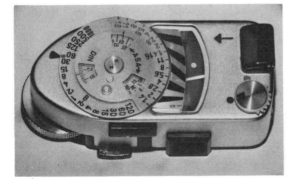

(Left) Front view of a reflected-light exposure meter.

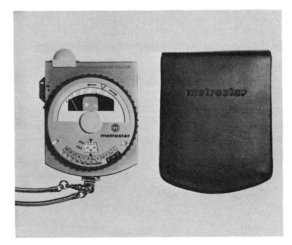

(Right) Some exposure meters, such as the Metrastar, are both reflected-light and incident-light meters. The small, white semi-globe (at meter's top left) converts it to an incident meter when slid over the window that admits light to its measuring system.

ond type of meter is the incident-light meter. It has a white cone or dome over its receiving cell. This cone combines highlights, shadow, and the various tones in between, and in use, it is directed toward the camera from the subject's position. It measures the amount of light striking the subject and translates this into shutter-speed and f/stop combinations.

Either type of exposure meter will prove worthwhile and a boon to your getting the most from your camera.

Many of today's cameras have built-in metering systems, or meters which may be attached and coupled with either aperture or shutter-speed dials. The built-in metering system usually requires nothing more than the user's lining up two indicators against each other. When this adjustment has been made, the camera has been set for the proper exposure. With an attached meter, the meter usually indicates the proper aperture for whatever shutter speed the camera is set, and it remains for the user to

set the camera's diaphragm to the indicated f/stop.

Exposure also may be determined, although not as critically, by making use of the information on the instruction sheet provided by the manufacturer with each roll of film. This sheet lists various lighting conditions and types of subjects and gives typical exposure data for each.

Similar to the instruction sheet is the exposure dial, a cardboard dial which can be adjusted to various lighting conditions and show proper exposure to be used under each, depending on the type of film.

Many photographers just guess at exposure. Fortunately, today's film has enough latitude that a reasonable guess will give you some sort of picture.

With the nonadjustable camera, of course, this is not a problem. If you follow the manufacturer's instructions as to film and lighting, you can't go wrong—although your picture-taking will, more than likely, be limited to bright sunny days.

4

THE SIMPLEST CAMERA

Somebody once asked, "Why buy a camera that can do *more* than you'll ever want it to do?" The question raises a valid point, one you would do well to take into consideration when you go out to buy your first camera. If outdoor snapshots are really all you want, a *box camera* might well be your answer. We've put the words "*box camera*" in italics, because the simple box cameras that gave birth to the name are no longer manufactured in that form. We refer, of course, to the black box of a generation ago (many of which are still rendering satisfactory service, we might add). Today's simplest cameras, although still box cameras in principle, are made of attractive plastics with improved lenses and, most of all, improved viewfinding systems. Adjustments are either nonexistent or quite limited, and by following the directions that come with the camera and the instructions of the film manufacturer anyone can come up with suitable snapshots.

There's a considerable variety of inexpensive cameras on the market today. They come in prices so low as to be almost negligible when considered in terms of the results they give.

DON'T UNDERESTIMATE THEM

Let's understand, though, that when we talk about simple cameras and their use for outdoor snapshots, we run the risk of implying false limitations on the versatility of these cameras.

In the first place, the fact that a simple camera has only one shutter speed, usually $^1/_{50}$ sec., which is not considered a fast speed, does not preclude its use for stopping action. There are four things you can do about photographing action.

(1) If you position yourself so that the action is coming toward the camera, rather than moving past it, you'll minimize the apparent movement in your picture.

(2) You can photograph the peak of action. In such movements as jumping, diving, or swinging a baseball bat, there's an instant at which the subject reaches a peak (for instance, the top of a jump). Even with $^1/_{50}$ sec. you can freeze this moment in your photograph.

(3) You can let the action blur. The blur itself often can contribute to the feeling of motion in a successful photograph.

(4) You can "pan" with the action. When a subject is moving you can follow it, moving the camera at the same speed as the subject, and when you release the shutter you will have stopped most, if not all, the action. However, the movement of the camera will blur everything in the picture that's not moving.

Second, although the simplest cameras have little, if any, aperture control, you can overcome this, to a large extent, by your selection of film. Films are rated according to their sensitivity. The more sensitive a film, the less light needed for registering a photographic image on it. So, for your outdoor pictures, you can use one of the less sensitive ("slower," according to the jargon) films; while for your indoor or poor-light pictures you can use a "faster" film. Even color films today run the gamut of sensitivity, and you can buy a color film to cover most photographic situations. However, if you don't intend to get very involved

in understanding photography, you'd do well to confine your color shooting to a good slow film with a lot of latitude outdoors under the most favorable sun-lighted conditions.

The box camera business took a great leap forward when Eastman Kodak introduced the Instamatic camera system, which became even more convenient when the pocket-size Instamatic was developed. One of the major features of this system is its method of loading film. The camera uses a specially designed film cartridge that has simplified casual photography by making loading practically foolproof. The Kodapak film cartridge has two chambers connected by a thin channel. The film feeds from one chamber to the other through the channel between them. The Instamatic cartridge contains 126-size film, giving you twelve or twenty 28 × 28mm pictures. The Pocket Instamatic cartridge contains 110-size film, which produces pictures that are 13 × 17mm. (The 126-size Instamatic slide comes back from the processor in a mount that fits a standard 35mm projector. The 110-size transparency, produced by the Pocket Instamatic Camera, requires a special projector, and Kodak does produce a separate line of Carousel projectors to accommodate the Pocket Instamatic slides.) Constructed so that it can't be inserted incorrectly, either size cartridge is simply dropped into the back of the respective camera, and the camera is loaded and ready to go.

There are quite a few 126-size and 110-size cartridge cameras on the market today. Eastman Kodak produces several of each, as do a number of other companies. Only a few of those on the market, however, can be classified as box cameras, since each of the others allows some degree of variation of exposure setting for different lighting situations, either manually or automatically. We'll refer to some of these later.

If you think you'd like to get more deeply involved in photography than just the box camera level but aren't sure, or if you want to learn photography gradually, or if you want to introduce a young child to photography with a little more than the most basic camera, you can do so without going overboard on price or camera complexity.

AND THE SLIGHTLY MORE COMPLEX

These are cameras which have, as advantages over the simplest cameras, some degree of aperture and shutter-speed control. However, the shutters don't go as fast or, for that matter, as slow as those in the more expensive cameras; and the iris diaphragms do not open as wide. The aperture limitation is, of course, a limitation of the lens. The maximum opening in a camera's diaphragm determines the maximum amount of light that can enter the lens containing it.

The slightly more complex cameras do, however, have faster lenses (which allow more light to enter) than the box-type cameras. Since they do open wider, they have, at the larger apertures, less depth of field than do the cameras with one lens opening, and that no more than f/8. These cameras open to as much as f/3.5 and even f/2.8. Since there is less depth of field, it is necessary to have some focusing method, and this will be found on most cameras with lenses faster than f/5.6. However, the focusing will be of the measurement type, which means you must know the distance between the camera and subject and set this distance on the footage scale.

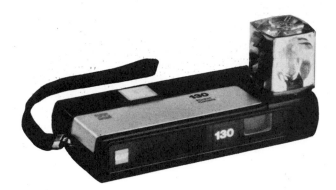

Eastman Kodak's Instamatic line starts with a simple, foolproof camera. Some models have built-in or attached flash holders and are flash synchronized for taking pictures under unfavorable lighting conditions. Instamatics compensate automatically for differences in film sensitivity.

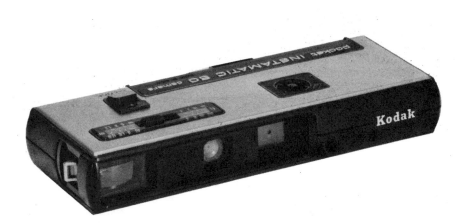

Pocket cameras vary, according to model and manufacturer, from extremely simple to fairly complex, with a good deal of automation available; and because of high quality of today's film, they produce very satisfactory results.

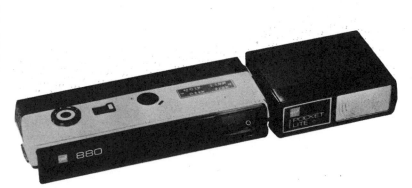

5

TWIN-LENS REFLEX

Although its popularity seems to be on the decline, the twin-lens reflex camera played an important role in the historic emancipation of professional photography from the large studio and press-type cameras. It was believed, for many years, that only the large negatives, 4″ × 5″ and larger, were of sufficiently good quality to render prints for commercial and journalistic purposes. However, it was proven that the high-quality construction of such twin-lens reflex cameras as the Rolleiflex produced negatives that gave prints as suitable for professional purposes. A few daring professionals introduced these cameras to the fields of advertising and magazine photography, and at one point, I'm sure, more pros owned twin-lens reflexes than any other type of camera.

The twin-lens reflex has given way in popularity to the even smaller 35mm camera and its advantages (to be discussed in the next chapter). For many people, however, the twin-lens reflex remains the easiest to operate of all professional-quality cameras. Among hand-held cameras, the twin-lens reflex is slow, almost cumbersome, to use, but it is still considered an easy camera on which to learn photography.

Some people object to the twin-lens reflex because of its size. But its size, really not a substantial objection, leads to an important advantage. It means that you don't have to enlarge every picture to get a simple usable print. A contact print, the cheapest and easiest to make, is exactly the size of the negative from which it is made. If you make a contact print from the normal 2¼″ × 2¼″ twin-lens reflex negative, you have a big enough print to use, to give away to friends and relatives, and even to carry in your wallet. Actually, there are two sizes of twin-lens reflex cameras, the 120-size, which uses 120 or 220 film and produces the 2¼″ × 2¼″ negative; and the smaller, now obsolete 127-size, which produces a 1⅝″ × 1⅝″ negative.

The twin-lens reflex camera has, as the name implies, two lenses. These are placed on the camera one above the other, and they serve separate functions. The bottom lens, known as the taking lens, is the one that actually takes the picture. The top, or viewing, lens is matched in size to the taking lens, and is used, of course, for viewing. Because of its closeness in position to the taking lens and their similarity in size, the viewing lens shows what the taking lens sees.

It works in this fashion. There is a mirror, placed at a 45-degree angle, behind the viewing lens. This mirror reflects the light entering the lens to a groundglass at the top of the camera. The user can see on the groundglass substantially that which will be included in the field of view of the taking lens.

Both lenses of a twin-lens reflex camera are mounted on a single panel at the front of the camera. This panel is movable for focusing. The image on the groundglass becomes sharp when the viewing lens is in focus. Since the taking lens is mounted on the same panel, and moves in and out in conjunction with the viewing lens, a sharp image on the groundglass means that the taking lens is focused.

There are two disadvantages to the twin-

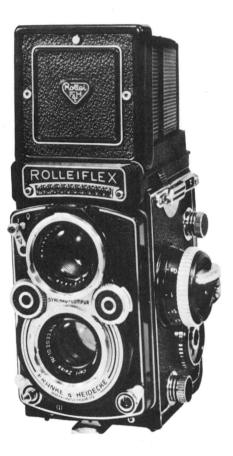

Today's Rolleiflex still employs the original viewing and focusing system that made it, at one time, the professional's standby camera. Among improvements are built-in regular and electronic flash synchronization. Some models, like this one, have built-in exposure meters.

lens reflex camera. One is the problem of lens interchangeability. Most twin-lens reflexes do not offer interchangeable lenses at all. The reason is, of course, that changing the taking lens also requires changing the viewing lens to match. Attachments converting these cameras to wide-angle and telephoto use are available, but these do not give the quality of full lenses. One twin-lens type, the Mamiya C series, has several interchangeable pairs of wide-angle and telephoto lenses, with the interchangeable assembly including a shutter.

The second disadvantage, parallax, is a slight one, and shouldn't bother most users at all. Parallax is the difference between the view of the top (viewing) lens and that of the bottom (taking) lens. Most twin-lens reflex cameras are adjusted to the point where this is quite minimal, and the parallax is noticeable only in extreme closeups. You'll learn to allow for this.

Although the image reflected on the groundglass screen is right side up, it's backwards. This doesn't create a problem with subjects that are standing still, but it can cause confusion when subjects are moving across the camera's field of view, giving the impression of moving in the opposite direction. Here again, practice is the solution, and after a while you'll get used to following action in your viewfinder.

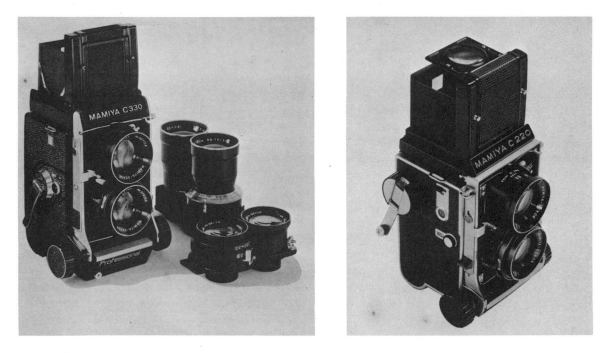

Interchangeable lens panel allows both the Mamiya C330 and C220 to use accessory lenses. With 80mm lens and bellows fully extended, the shortest distance from film plane to subject is 13$^{15}/_{16}$ inches (35.4 cm).

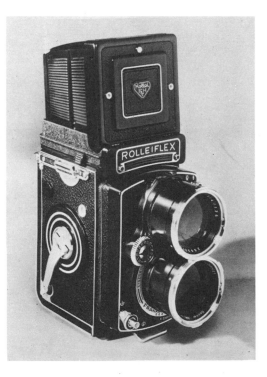

Although interchangeability still is not featured on the Rolleiflex, one model comes with tele-photo (135mm) lenses in place of the normal (75mm) size.

6

THIRTY-FIVE MILLIMETER RANGEFINDER

To a large extent, the 35mm still camera owes its existence to the movies. In 1924 a German movie-maker invented a still camera he could use with standard professional (35mm) movie film. The basic purpose was to test the film and his exposures before going to the trouble and expense of filming a movie sequence. The advantages of this little "candid" camera were readily apparent, and it went on to become the Leica, grandfather of all 35mm cameras, and still a leader in its field.

Today's 35mm cameras are sharply divided into two categories—the rangefinder type and the single-lens reflex type. Since the single-lens reflex has, in recent years, boomed into a field of its own we'll discuss this system in the next chapter, confining this one to the rangefinder type.

One of the major advantages of the 35mm camera is the speed with which it can be used. Although complex in design and function, this camera can, through your familiarity with it, become one of the simplest to use, therefore one of the fastest. The very nature of the built-in rangefinder adds to this speed and simplicity. As with most cameras, shutter speed and lens aperture must be preset. It's with focusing, tripping the shutter, and film advance that the 35mm camera outstrips them all. What can be easier than this: You look through the rangefinder (combined, in modern 35mm models with the viewfinder) window and see two images; by turning the lens barrel slightly you bring these two images together; the instant they combine you're ready, just through the natural position of your hand while holding the camera, to release the shutter; and then, without even removing the camera from your eye you can, by a sin-

gle thumb movement, advance the film, cock the shutter, and be ready for the next picture. During the time it took you to read this paragraph you could have taken a dozen or more pictures with a 35mm camera.

There are two other chief advantages to the 35mm rangefinder camera: size and interchangeability. The advantages of its size are obvious, and being small, it's also lightweight, so that a 35mm photographer can have a camera with him practically all the time. Many 35mm cameras can be carried in pocket or purse; some even have collapsible lens mounts, which means the lens can be shortened by sliding part of it into the camera body when the camera is not in use, making them still more compact for convenient carrying.

The interchangeability featured in 35mm cameras has reached a point where it is somewhat amazing. By interchangeability we mean the switching of lenses and viewfinders to suit specific requirements. The normal lens for a 35mm camera has a focal length of about 50 millimeters. The focal length of a lens is simply the distance between a measuring point on the lens when it is focused at infinity and the focal plane of the camera. For each film size there is what is called a *normal* focal length, and this is the lens size which would give the most undistorted image to that particular film size. The focal length of a lens, however, also affects the lens' angle of view. A 50mm lens has an angle of view of 46 degrees. However, on many occasions a photographer wants to increase or decrease

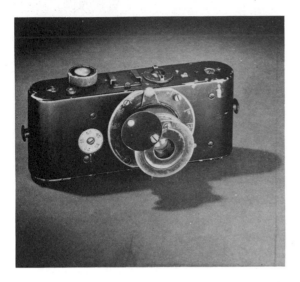

Although bearing some physical resemblance to the original 1924 version (above), today's Leica (right) features: a highly refined, bright viewing system; a built-in rangefinder that couples automatically to all its lenses and is visible through the viewfinder window; a built-in, behind-the-lens exposure-metering system that flips out of the way an instant before the shutter opens; a rapid film-advance lever; a self-timer; and viewfinder frames that change automatically to accommodate accessory lenses.

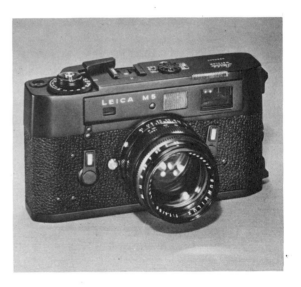

this angle—to get more or less into the picture. He accomplishes this by changing from his normal lens to one of a different focal length. A lens with a focal length of less than 50mm and an angle of view of more than 46 degrees is called a *wide-angle lens*; the opposite, a lens with a focal length of more than 50mm and an angle of view of less than 46 degrees is called a *telephoto lens*. A wide-angle lens serves the basic purpose of allowing you to get more into the picture than you would with a normal lens without having to step back (which may not always be convenient or possible). A telephoto lens, on the other hand, fills your negative with less than your normal

lens would have, eliminating objects between you and the subject, thereby apparently bringing the subject closer to you.

Not all 35mm cameras provide for interchangeability of lenses, so if there's a remote possibility that at some time you will want to buy an accessory lens, make sure, when you buy your camera, that lens interchangeability is possible.

There are a couple of other things you should consider when buying a 35mm camera. One of them, believe it or not, is size. Although the 35mm camera is, by its very nature, a small camera, there are varying degrees of smallness within the category. After the first 35mm cameras came into

(Above) View through the rangefinder shows a double image when the camera is out of focus.
(Below) When the camera is focused the two images merge, and you're ready to take the picture.

being, manufacturers spent many years sophisticating them, and generally speaking, that meant adding features—usually having to do with flash synchronization or exposure-measuring devices. From all this, there developed a pretty big "small" camera. More recently, there has been a trend toward miniaturization or "compactness." One of the first modern compact 35mm rangefinder-type cameras to appear on the market was the Rollei 35, manufactured by Rolleiflex. They had been, until then, the makers of the most popular twin-lens reflex system, the 120-size Rolleiflex (still the top twin-lens reflex) and its less expensive, slightly less sophisticated brother, the Rolleicord. (We put the Rollei 35 into this rangefinder category, but it really isn't qualified, because it doesn't actually have a built-in, optical rangefinder system—which probably is why it continues to be the smallest of the lot—and focusing is accomplished by setting a distance scale.)

Other compact 35mm cameras, however, such as the Leica CL and the Olympus 35 RC, have all the features of their bigger brothers, and yet are small enough to fit into a pocket or purse. Others have some of the features, but because exposure is either automatic or semi-automatic (without the override privilege offered by the little Leica and Olympus), they don't offer the user all the control he has with a camera that allows him to set exposures manually, if he so pleases. Also, not all compact 35mm cameras allow for lens interchangeability, a feature to be considered.

One other matter to look into when buying a 35mm camera is its built-in exposure-determining system. Most cameras today have these, and you should think about them in the light of the kind of photography you plan to do. Ask yourself, first of all, whether the system (or built-in exposure meter) can accommodate the range of film speed you will be using. And if you have any intention to underexpose black-and-white film (which will be compensated for later on

Top view of Leica M-5 shows simplicity of this very sophisticated camera's controls. DIN and ASA numbers refer to film speed and are related to built-in exposure-metering system. Shutter release is in center of shutter-speed dial. Dial at far right is exposure counter. Scale at front of lens barrel indicates aperture settings; center scale shows distance between film and subject in both feet and meters; rear scale indicates depth of field according to choice of aperture settings at distance shown on distance scale.

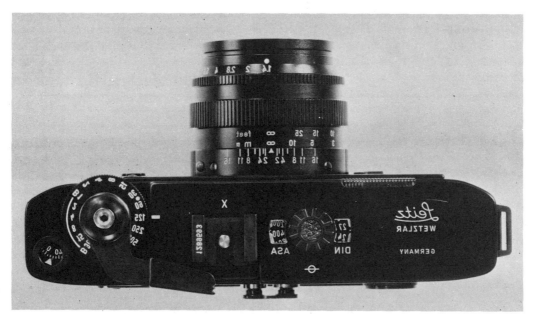

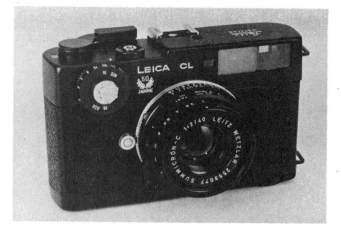

Leica CL has practically all the features of its larger brothers, including built-in exposure meter, lens interchangeability, and single-window viewfinder/rangefinder system.

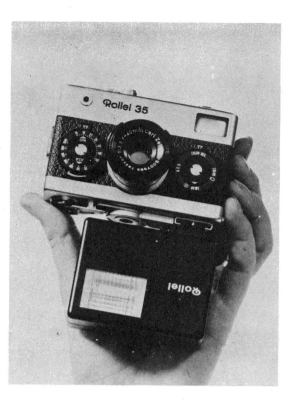

Rollei 35, shown with electronic flash attached, produces full-size 35mm negatives from a miniature-size camera with most full-size 35mm features. However, it lacks a built-in rangefinder and lens interchangeability.

by overdevelopment), will your camera's built-in exposure-determining system accommodate the fastest film and speed rating that you will use? You should also check the system's sensitivity. If you have any interest in taking pictures in low-light situations, make sure that your camera's built-in meter will work in dim light.

You'll notice I said earlier there were *two* chief advantages to 35mm (in addition to the possibilities for speed of operation). If this book had been written a couple of years ago I might have said three, and the third, the one I've now eliminated from major importance, would have been the most important of the three for most photographers. This other advantage is lens *speed*. This means that the maximum apertures of many lenses for 35mm cameras were such that pictures could be taken under very dim lighting conditions. This situation still exists, with *f*/2 and *f*/1.4 being quite common among the better 35's, while *f*/3.5 and *f*/2.8 continue to be normal for the 120's. How-

ever, it has lost its importance to a large extent because in recent years film manufacturers have increased film sensitivity to the point where pictures can be taken in almost any light if the right film is selected for the individual situation.

There is one disadvantage to 35mm that continues to stand out and is worth considering before you buy your camera. This is negative size. Because the negatives are so small, about an inch by an inch-and-a-half, each picture has to be enlarged to be worthwhile as a print. If you should decide to do your own darkroom work this disadvantage could be minimized; if you have your developing and printing done "out," the business of having to enlarge each frame could become quite expensive. Professionals who use 35mm cameras find this tolerable because, for the most part, they either do their own enlarging or find it worthwhile to have it done by a lab because their pay for the picture covers the expense of the printing.

7

SINGLE-LENS REFLEX

The single-lens reflex camera (particularly the 35mm size) is the most popular type of sophisticated camera on the market —with more models available and a broader range of prices than any other category.

What is a single-lens reflex camera? It works, partially, on the same principle as the twin-lens reflex, which we discussed in Chapter 5: The user sees through a lens rather than through a conventional viewfinder. However, with the single-lens reflex the user sees through the same lens that's used for taking the picture. It works, basically, in this fashion. There is a mirror behind the lens set at a 45-degree angle, reflecting the image upward to the viewing and focusing system. However, the shutter release of the single-lens reflex is coupled with a mechanism which releases the mirror as well. Therefore, when the shutter release is pressed, the mirror flips up and out of the way an instant before the shutter opens, allowing the light to get back to the film.

There are two types of viewing systems for SLRs. One is a groundglass viewer, much the same as that on the twin-lens reflex, allowing the user to operate the camera by looking downward at the groundglass screen on which he does his focusing and viewing. The second is the pentaprism viewer, which contains a five-sided prism to pick up the reflected image at the point of the groundglass, invert it, and reflect it back to an eyepiece, so that the camera is then used at eye-level in a position similar to that used with a rangefinder camera.

Although the basic system is the same on all makes and models, there is a good deal of variety in SLRs. This is a result of the peculiarities brought on by the system itself. For instance, because the viewing and focusing is done through the taking lens, the lens' diaphragm should be kept fully open during the viewing and focusing to permit the user to see the brightest possible image. It's not likely you'd want to view and focus, then take the camera down from your eye in order to set the diaphragm for the picture, raise the camera to your eye again, and shoot, seeing, this second time, a very dim image.

Manufacturers have discovered two solutions to this problem. One is the "automatic" diaphragm; the other is the "preset" diaphragm.

With the automatic diaphragm a spring mechanism is built into the diaphragm mount. Before lifting camera to eye the user selects the aperture he will be using and sets an indicator dial to the proper *f*/number. However, setting the dial does not move the leaves of the iris. Instead it puts a stopping device into position. This device will stop the iris leaves so that they will not close down beyond that predetermined point. When the photographer presses the shutter release he releases the automatic diaphragm spring mechanism, and the leaves of the iris diaphragm stop down to the predetermined opening. This happens during the same fraction of a second, before the shutter actually opens, as the raising of the mirror.

With the preset diaphragm a similar event takes place. However, this is manual, and the speed of its happening depends on the

In the SLR, the light enters the lens, reflects upward off a mirror, passes through a groundglass, and finally goes through a prism, which inverts and reverses it.

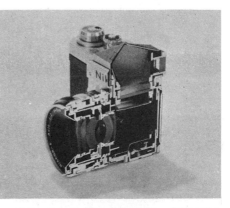

This cutaway view of the Nikon F shows a cross section of the pentaprism and its relation to the viewing system. The mirror is in the "up" position.

photographer, who sets a stop to a predetermined point, but then, with the camera still at his eye, flips the actual diaphragm-setting ring by hand as far as it will go (to the predetermined aperture) and then presses the shutter release.

More variety in styles of SLRs depends on the types of shutter used. Some cameras have focal-plane shutters, which means there is nothing but the mirror and the diaphragm to operate before the shutter opens to let in the light. Other single-lens reflex cameras have between-the-lens, leaf-type shutters. Since this type of shutter is in the lens barrel, and therefore in front of the mirror, it must be kept open during viewing and focusing in order for the light to get back to the mirror. So in the case of a single-lens reflex with a between-the-lens shutter, the shutter must remain open during viewing and focusing. The mirror, in its down position, keeps the light entering the lens from striking the film. When you press the shutter release, these things happen. The shutter closes, the mirror goes up, the diaphragm closes down to the predetermined aperture, and then the shutter opens for the length of the exposure and closes again.

With most single-lens reflexes all the automatic actions are reset automatically when you advance the film. The movement of the film-advance lever also lowers the mirror, opens the shutter (where necessary), and opens the automatic diaphragm. On some older cameras the diaphragm has a separate cocking lever, and this must be operated in order to set the diaphragm for automatic closing down. On most newer SLRs there is what is known as an "instant-return mirror," which drops down again, automatically, after the shutter's action has been completed; this does away with between-shot "blackout," when, with the mirror up, the user cannot see through the lens.

Although the single-lens reflex is the most popular camera on the market, it continues to be the subject of some controversy among photographers, with adamant issue being taken over its advantages and disadvantages.

The disadvantages might be apparent from the foregoing description of the camera's basic principles—that there is a delay between the time the shutter release is pressed and the time the picture actually is taken, making it possible for the subject to have changed position, $1/40$ to $1/25$ of a second's worth, giving you a picture other than what you saw in the viewfinder; and that there are so many functions to the camera other than the simple opening and closing of the shutter that the camera would be inclined to shake or move at the slow speeds or with the heavier (telephoto) lenses.

On the plus side are these arguments: In the first place there is no *parallax.*

To define parallax we must point out that when two separate lenses or a lens and a separate viewfinder are aimed at a single subject there is bound to be (no matter how slight the difference between them) some difference in the angles at which the subject strikes them individually. This difference means that neither will include exactly the amount of the subject included in the other. The difference is called parallax. Ordinarily, there is so little parallax in most shooting situations as to be not worth worrying about. But as the camera gets closer to its subject this parallax increases, and it can become something of a problem. With many cameras, focusing on close subjects automatically changes the angle of the viewfinder to compensate for the parallax to a very great extent. On other cameras this can be done manually, with an adjustment lever.

With a single-lens reflex there is no parallax because you are looking through the lens that will be taking the picture, and your eye sees, therefore, exactly what the film is going to "see." This is quite a convenience for exact placement of the individual parts of the subject in relation to each other.

The second advantage stems from the fact that when telephoto lenses are placed on rangefinder cameras, image size in the viewfinder does not change. The viewfinders are adjusted by reducing the size of the frame to include only that area included in the final picture. With the longer telephoto lenses this becomes a problem because the viewfinder is reduced to such a size that it is almost impossible to see what's getting into the picture. The only remedy for the rangefinder camera user is to add a supplementary viewfinder to his camera with its obvious inconveniences—having to switch the eye from the rangefinder window to the supplementary viewfinder, and having to worry about even more parallax. With a single-lens reflex you always get a full image in your viewfinder because you see the same *magnification* your film records.

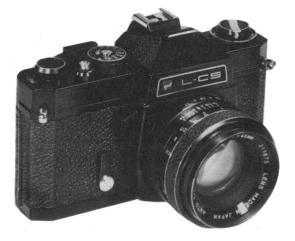

GAF's L-CS is a 35mm single-lens reflex featuring interchangeable lenses, a built-in exposure meter, and through-the-lens viewing, focusing, and metering.

The full pentaprism SLR differs in appearance from other 35mm cameras by the obvious absence of the rangefinder and viewfinder windows from the front of the camera.

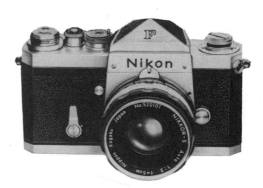

The third, and to some the most important, advantage of the SLR system is this: By looking through the taking lens you can actually *see* the depth of field of your picture. If you want to manipulate it you can change your aperture, stop and check again until you have exactly the depth of field you want in your picture. This is of special importance to photographers who are more interested in having specific areas *out* of focus than *in* focus.

Although we talk about single-lens reflexes as though they were confined to the 35mm size, there are some excellent 120-size single-lens reflexes on the market as well. Therefore, if your preference runs toward the larger negative or color transparency, you can still have the advantages of a single-lens reflex camera.

In determining which single-lens reflex camera to buy, you should consider one feature in addition to the obvious ones, such as price, lens interchangeability, size, flash synchronization, and exposure-determining system—the viewing-focusing screen. The photographic image that comes through the lens, reflects off the mirror, passes through the prism, and finally, focuses on the viewing-focusing screen is the image that you see when you look through the viewfinder. There is a variety of screen types. Some show brighter images than others, but the big differences lie in the focusing methods they offer. These range from a simple groundglass—similar to that on a twin-lens reflex camera, on which the image appears clear and sharp when the camera is in focus—to a screen with a center circle that contains a split prism, which allows you to focus by the rangefinder method as well as on the groundglass. Some cameras offer one type of screen, some offer another, and some cameras offer focusing-screen interchangeability, which means you can equip them with whichever screen you find most comfortable. The latter type of camera even allows you to use different types of screens for different types of photography—if you get to the point where that becomes important.

In any case, before you leave the shop with whatever camera you buy, make sure that you can view and focus with it comfortably. If you wear eyeglasses, the viewfinder should still allow you to see the entire viewing-screen area.

An example of the straight groundglass viewing SLR is the Hasselblad 500C. The image reflected onto the groundglass is backward, as with the twin-lens reflex.

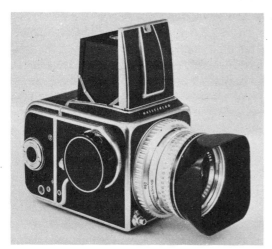

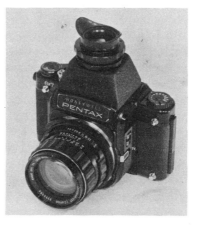

Some 120-size SLR's, such as Honeywell Pentax 6 x 7, include the same image-erecting, prism-viewing and focusing systems as 35mm SLR's. In appearance, they resemble 35mm cameras, although they are substantially larger and heavier. Camera comes with regular eye-level viewer—system shown here is accessory.

8

SUBMINIATURE AND HALF FRAME

When 35mm still cameras were developed they were given the classification of "miniature," because it didn't seem likely that still camera formats could get any smaller. However, they did, and here again, still photography owes a debt to the movies; the next movie film size down from 35mm is 16mm (about half), and it was to this smaller film that the manufacturers turned, for the most part, for the next reduction. Since the term "miniature" already was in use, they called the new class subminiature, or ultraminiature, interchangeably. Please note, though, that not all subminiatures use exactly the same film size: some are a little smaller than 16mm, some use perforated (for movie cameras) 16mm film, and still others use unperforated 16mm film. By eliminating the perforations along the edges they get a somewhat larger negative. This diversity makes for one of the disadvantages of subminiatures.

The subminiature camera on today's market has a history of more than 40 years. It was back in 1934 that a Latvian named Walter Zapp went to work designing a camera that would be small enough to be carried around in the pocket—not necessarily a spy camera, but a camera for general use. He came up with the first Minox, which went into production in Riga in 1936, and some 17,000 of these cameras were sold before World War II. After the war ended, the Minox factory was established in West Germany, and about a quarter of a million Minoxes have been sold since then. Their general acceptance by the camera-buying public is reflected in the fact that by the mid 1970's there were more than a dozen companies producing subminiatures—partly due to Pocket Instamatic popularity.

But what about these subminiatures, anyway? Are they really worthwhile? Will they give decent results? Are they of any value to the professional?

Well, on the one hand, subminiatures, as they now stand, cannot be considered professional cameras, although many professional photographers own them. For the pro, the problem is one of quality in the finished product, the enlarged print. Although many of the cameras themselves really are high-quality precision machines, the fact remains that enlarging these tiny negatives to 8″ × 10″ or 11″ × 14″ prints results in the loss of quality that one would be certain to expect from such extreme blowing up.

On the other hand, the amateur, the casual snapshooter, has little if any use for such large prints, and when it comes to wallet size, or 3″ × 4″, or even 4″ × 5″ prints, the results produced by most of the subminiatures can be amazing in their excellence.

There's a problem in talking about all subminiatures as a class, since, as with the other groups, they run the gamut in both price and quality. Prices of subminiatures start as low as $14.95 and go as high as $400, with quality following suit. The full range of Pocket Instamatic cameras, naturally, falls into this category.

By and large, though, the greatest advantage to subminiatures is the convenience that results from their size. Many's the time I've said, and heard said, some variation of the phrase, "If I'd only brought a camera along," as the speaker gazes dolefully at

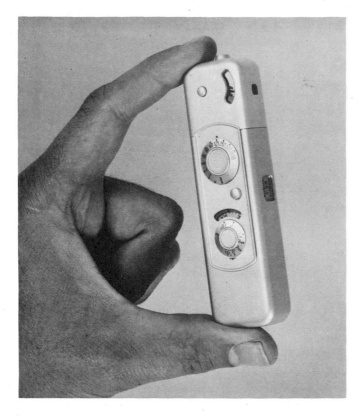

The Minox BL Private Eye has a 15mm f/3.5 lens and can focus down to 8 inches. It also features scale focusing with measuring chain, parallax correction, and a built-in, center-weighted exposure meter.

Handy subminiature caught this airline stewardess in action. Tiny film resulted in grainy but very satisfactory enlargement.

some vanishing once-in-a-lifetime picture opportunity. Having a camera with you at all times is, of course, the remedy, and let's face it, the only type of camera you can carry with you at all times is one that's small and lightweight enough to fit unobtrusively into pocket or purse. You could carry a subminiature camera and enough film to take a couple of hundred pictures all in your pocket without making a substantial bulge. Obviously, this is particularly handy when taking a trip, or if you just don't feel like carrying a gadget bag or other encumbrance.

Another advantage is the short focal length of the lenses that come on most subminiature cameras. The rule is this: The shorter a lens' focal length the greater its depth of field. Wide-angle lenses for all cameras give greater depth of field than do the so-called "normal" lenses for these cameras. The rule, of course, reaches down

to the subminiatures which have, by their very nature, lenses which give great depth of field. This eliminates the need for critical (sometimes time consuming) focusing, since a general distance setting will, ordinarily, include in its area of sharpness just about everything you'd want to get in sharp focus in your picture.

This is considered by some photographers to be a mixed blessing, because the manufacturers of most subminiature cameras have taken advantage of the great depth of field to eliminate optical rangefinders. Focusing is done by measurement or guesstimate of the distance between subject and camera. Therefore, the extremely critical focusing necessary to professional photographers is eliminated in favor of a certain amount of gamble. (We should point out that adding a rangefinder means adding size and weight to the camera.)

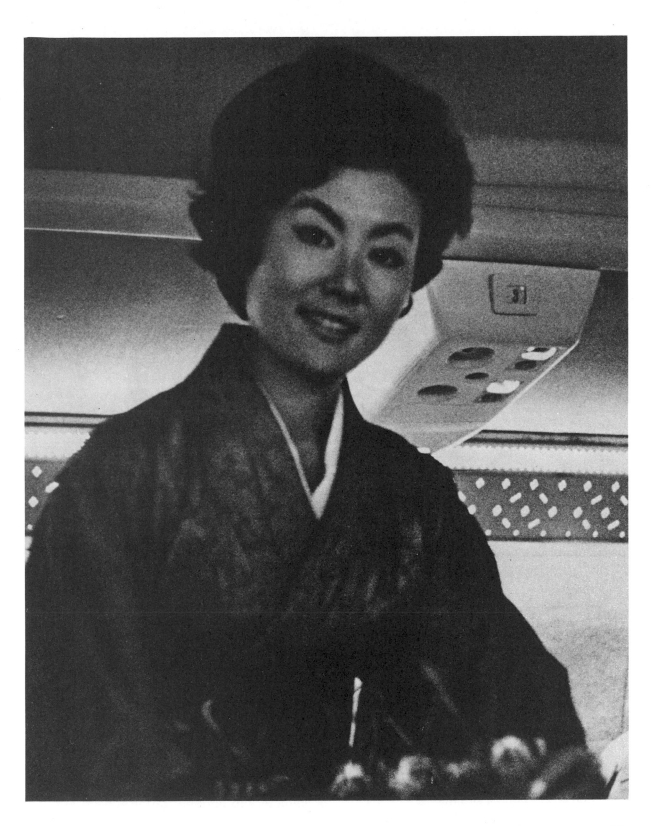

Today's popular subminiatures do not offer lens interchangeability, but on the plus side, many of the subminiatures feature one thing most other cameras can't offer, and that's the possibility of using them for extreme close-up work, such as copying documents or photographing small objects. Some 35mm camera makers are pretty impressed with the fact that their cameras will focus on objects as close as 18 inches. But some subminiatures go down to eight inches, and some of the others have simple clip-on attachments that allow them to move in for extreme close-up work.

There's no doubt that the prospective buyer of a subminiature camera will go through a certain amount of conflict. First of all, he'll have to agree that its use is going to be restricted to snapshots, and he must decide how much he wants to spend for a snapshot camera of this nature. Most of the subminiatures bear a strong resemblance to each other, so he must reconcile the price difference. Probably the best way to go about deciding is to check the cameras feature for feature against each other, keeping in mind that size and weight are features to be considered, since it's very likely he's decided on a subminiature for this very reason. Another important comparison to make is of the number of accessories available, and what they'll do that interests him.

It's a fact that subminiature cameras require a certain amount of getting used to. Once you've mastered one you'll be amazed at the excellence of your snapshots.

Between subminiature and 35mm is another camera size that made great strides for a while. It's known as either "half frame" or "full frame," depending on the individual manufacturer, but there the disagreement ends. All use regular 35mm film in cartridges, which gives them the advantage of all the variety of film speeds and types manufactured for 35mm cameras, as well as the universal availability of 35mm film.

The two names for this category both mean the same thing, to all practical intents and purposes. They give you a picture that's half the width of the conventional 35mm frame (with twice as many to a roll of film), which accounts for the first variation of its name. The title "full frame" comes from the purists who declare that the picture is the same size as a 35mm *movie* frame, and since 35mm film was used for movies before the advent of the 35mm still camera with its elongated picture, the new arrivals are simply reverting to the full movie frame.

But whatever you want to call them (I prefer "half frame"), there's a lot to be said for them. In the first place, there's the business of film availability mentioned earlier. Second, they're small—some are as small as the large subminiatures—which makes them convenient to carry in pocket or purse. Third, many are of extremely good quality.

As with the subminiatures, the half-frame cameras have relatively short focal-length lenses (normal is 28mm), which gives them greater depth of field than that of normal lenses on the larger cameras and eliminates the need for precise focusing aids, such as rangefinders.

The half-frame camera, as a standard size, has experienced a truly meteoric history. At one point, in the early 1960's, when half-frame was the only thing in the market between 35mm and subminiature, there were lots of brands and models available. But the introduction of the 126- and 110-sizes (Instamatic and Pocket Instamatic systems) on the market pushed the half-frame camera right out of popularity. Only a few are being manufactured today. Even the Olympus people, once very active pioneers across the entire half-frame field, today have only a couple of half-frame models in production. Instead, the company has switched to full-size 35mm. But they haven't gotten completely away from their commitment to miniaturization—theirs are

among the smallest 35mm rangefinder and single-lens reflex cameras.

Half-frame slides are returned from the processor in regular 2″ × 2″ mounts, with half-frame instead of 35mm cutouts, which allows them to be used in 35mm projectors —even interspersed between full 35mm slides.

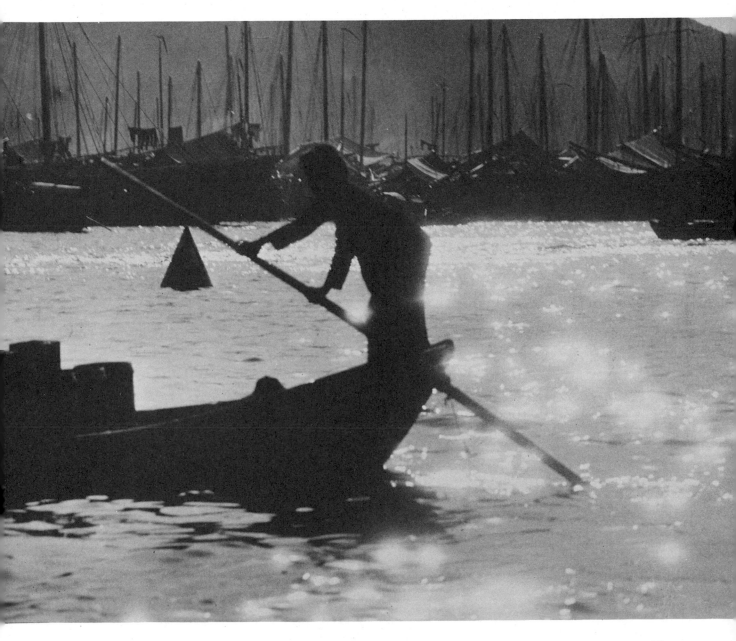

9

POLAROID LAND CAMERA

In the first place, let me point out that the Polaroid camera is not magic, and in the second place, there is no "catch" to it. It does what it claims to do; specifically, give you a finished picture in a minute, give or take a few seconds, after you've snapped it.

Is this photography? And is it possible? The answer to both questions is "yes."

The Polaroid process is photography, right down the line, but it isn't conventional photography as most of us know it. The camera, of course, is a camera, with lens, shutter, and focusing provisions. There is film, there is a negative, and the picture is developed by a chemical process in the dark. Operating the camera, lens, and shutter, right down to snapping the picture, is near enough to conventional photography to be considered such. It's in the film, its development, and the transfer of the image from negative to print that the Polaroid departs. There are two ways to explain this, a highly technical one and a very simple one. I've chosen the simple one, and it follows.

The Polaroid "film" contains everything necessary to make a finished print in a Polaroid camera; that is, it contains the light-sensitive negative material, the printing paper, and the chemicals.

Originally, Polaroid film came in rolls. The company no longer makes the big, bulky cameras that accommodate its roll film, but, I have been advised, it plans to continue manufacturing the film for as long as the early models are around to create a reasonable demand. (If you have one of the old cameras and if your dealer does not carry the film for it, write directly to the company.) Polaroid cameras presently on the market (with the exception of the SX-70) use **the** convenient film pack.

In **any ca**se, here's how they work. With the roll film, each roll is made up of two rolls, one negative and one positive. The film pack, which is flat, is much the same, but each negative-positive set is a separate unit.

Once the film is in the camera and in position, you take a picture as you would with any other camera. If the model you're using requires manual setting of aperture and shutter speed, you set these. If it's automatic, you need only be sure that it's set for the type of film in it. When you release the shutter, the light enters the camera, just as with other systems, and exposes the film.

With other systems you would, at this point, advance the film, take another picture, and continue to do so until you have exposed the entire roll. Your roll of film would contain a series of exposed, latent images, ready for development. This conventional film would then be treated chemically (*developed*), and whichever parts of it were touched by light would become black, or various shades of black, depending on the various intensities of light that struck it. The black image would be fixed so that further exposure to light would have no effect on it, and all parts untouched by light would be dissolved, so that you would have a piece of transparent material with a black, reversed, or *negative,* image on it. To make a print you would allow light to go through this negative material and strike a piece of light-sensitive paper. The light would go through the transparent parts of the film, and these areas would turn black when the paper was developed chemically. The light

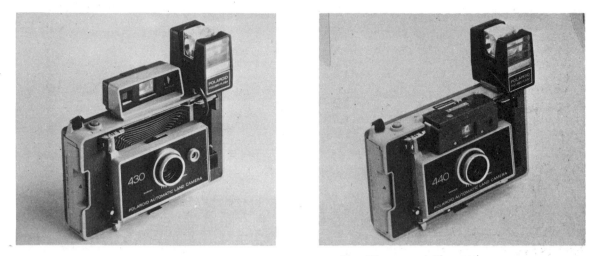

The Polaroid 400 Series Color Pack cameras, a four-camera series, utilize a special focused-flash system. Other features include electronic shutter, development timer (except on the Model 420), and electric eye.

would not go through the black parts of the film, so these areas would remain white. The image, then, would have again been reversed, resembling the original subject. And you would have a photograph.

How does the Polaroid system, the invention of Dr. Edwin H. Land, get around all this?

It's quite simple—now that it's been invented. With roll film, after snapping the picture you pull the paper leader until it stops automatically. By pulling the leader you've done several things. You've moved the negative material up to a point where it joins the print paper, and you've pulled the two of them through a pair of heavy rollers. Attached to the print paper, at the point at which it entered the rollers, was a little "pod." This pod contained, in jellied compound, all the chemicals needed to develop the film. The pod preceded the negative and print paper through the rollers, and it was broken. Then, as the other two pieces of material were drawn through the rollers, the contents of the pod were spread evenly between the two sheets. These chemicals developed the film. The image from the film

(in the form of metallic silver) was physically transferred to the print paper.

The entire development and transfer of the picture from the negative to the paper takes just 15 seconds. So, a fourth of a minute after you pull the leader through you are able to open the back of the camera and remove the finished picture. With roll-film models, the print and negative come out of the camera with the leader, and after 15 seconds the print is lifted off. All the chemicals remain with the negative, and you have a clean, dry print. The negative remains with the roll of film, is pulled through as part of the leader, and is torn off and discarded.

With film pack, the process is the same, although the method is slightly different. When you loaded the film, you left a white tab sticking out of the camera. After taking the picture, you pull it free of the camera. This moves the exposed negative from the film plane into position where it faces the positive material, and both are ready to go through the rollers. At the same time, a second tab appears at the point where the first was. You pull the second tab, which draws

48

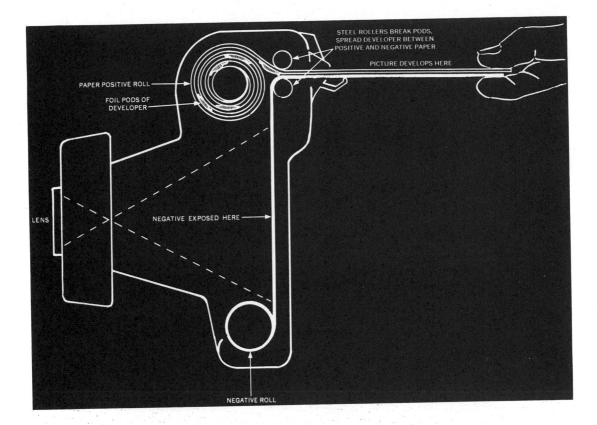

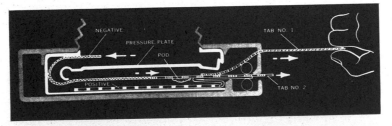

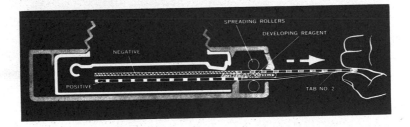

The above diagrams show both film pack and roll film systems as described in the text. The uppermost diagram gives an inside view of a Polaroid Swinger camera, showing locations of negative and positive rolls and how they are brought together and the development process started. The film pack setup, with two tabs, is shown in the lower two diagrams.

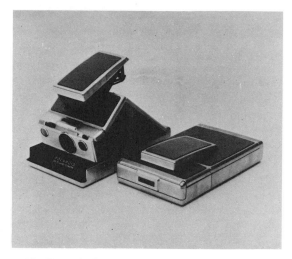

The Polaroid SX-70 is an instant color-picture system. Compose, focus, and shoot. Self-developing photo ejects two seconds later.

the combination (negative, positive, and developing agent) between the rollers, initiating the developing process by bursting the pod. The entire film assembly comes out of the camera, and after 15 seconds, the positive, which has become a finished print, is separated from the negative, which is then discarded.

The advantages of the system are obvious. First there is practically no delay between the time you take a picture and the time you have a finished print. Second, you know immediately whether or not your picture is "going to come out." If it doesn't, you shoot another.

For the disadvantages, with the exception of one, Polaroid has come up with some service, gadget, or new development that provides satisfactory solutions. The one disadvantage not overcome so far is the camera's size. It's big, because the system requires a certain minimum amount of space; but even this must be taken with tolerance when it is considered that in one instrument you have both camera and darkroom.

One complaint was that the film was not very sensitive, and that acceptable pictures could be taken only outdoors in bright sunlight, or with the aid of supplementary lighting equipment, such as flash or floodlights. This has been overcome, gradually, with the development of increasingly sensitive films, until there is now a Polaroid film so sensitive (Polaroid 3000) that it can be used under conditions still impossible for conventional films.

The Polaroid Land people handled the question of color film nicely—by inventing their own: Polacolor Film. Conventional film is coated with three layers of emulsion. Each of these is sensitive to one of the three primary colors, and all color in photography comes from combinations of them (see Chapter 14). Polacolor Film goes along to that extent. The difference is this: With conventional color film the actual color (dyes) is introduced during one of the stages of the development. Polacolor Film doesn't have access to a multi-stage laboratory development process in which this can be done. So Polaroid increased the number of layers of emulsion to the required three, and added the dye molecules to the film, along with a chemical process to make them work. The result is a film that functions as Polaroid black-and-white does.

Polacolor Film has a speed of ASA 75. It's a daylight-type film, which can be used unfiltered with blue or electronic flash and by photoflood with the proper conversion filter (which reduces the speed to ASA 12).

Another major objection was to the product being, after all, merely a print, a single print of substantially less than exhibition size. Polaroid has come up with an answer to this: the print copying service provided by the company itself. You can, for a minimal charge, send your print to the company, who will make either a copy print or a copy negative, which is on regular film and from which you or any processor can make prints of any size you'd care to have.

Just about all other objections to the Polaroid Land system were resolved by the introduction of the SX-70 camera, which is a

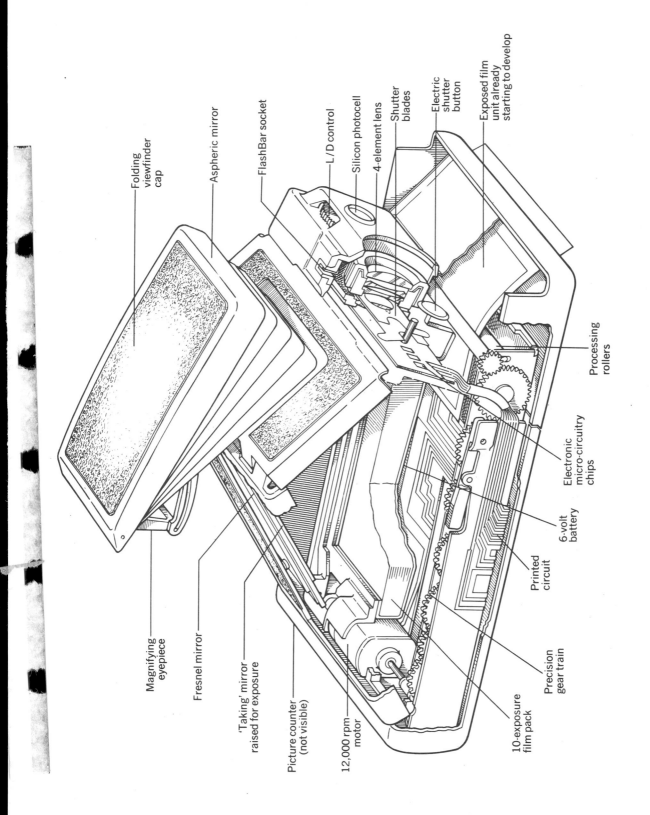

Folding viewfinder cap

Aspheric mirror

FlashBar socket

L/D control

Silicon photocell

4-element lens

Shutter blades

Electric shutter button

Exposed film unit already starting to develop

Processing rollers

Electronic micro-circuitry chips

6-volt battery

Printed circuit

Precision gear train

10-exposure film pack

12,000 rpm motor

Picture counter (not visible)

'Taking' mirror raised for exposure

Fresnel mirror

Magnifying eyepiece

Parts nomenclature of the Polaroid SX-70 Land camera.

The Super Shooter uses six different Polaroid films. It is fully automatic and has a built-in flash. The viewfinder adjusts automatically to show the format of film in use.

completely automatic system (even removal of the exposed film from the camera). With the SX-70, the user has only to focus the camera and push the shutter-release button. Exposure is controlled electronically, and an electric motor (powered by a battery built into the film pack) drives the exposed sheet of film through the processing rollers and out of the camera. The film emerges as a single sheet, the positive only, eliminating the negative and the necessity for disposing of that messy piece of chemical-covered material. Although the film comes out of the camera within half a minute after the exposure is made, development still takes from five to ten minutes, but this represents no problem because it goes on automatically, after the film has come out of the camera.

The SX-70 is lighter in weight than most other Polaroid models, and it's easier to carry because it folds up into a very flat package, about an inch thick, four inches wide, and seven inches long, when not in use. In use, it differs from other Polaroid Land cameras principally because it is Polaroid's first single-lens reflex camera. Its electronic shutter controls exposure over a wide range of lighting conditions, from very dim (requiring time exposures) to bright. Flash, also, is controlled automatically. The standard flash unit for the SX-70 is General

Electric's Flashbar 10, a single unit containing ten flashbulbs that coincide with the ten sheets of film in each SX-70 film pack.

If you decide to buy a Polaroid Land camera, as either a primary or secondary camera, you can choose from a fairly wide selection of models. The line starts with the Square Shooter II, a color-only automatic model with scale focusing, priced at about $25. It's one of the rigid cameras, and it uses a smaller film pack than do the folding, more expensive color pack cameras. The finished print from the Square Shooter II has a picture area of $2^3/_4'' \times 2^7/_8''$ (practically square).

The folding-type color pack cameras have coupled rangefinders and eye-level viewfinders, use both black-and-white and color film, produce a print with a picture area of $3^1/_4'' \times 4^1/_4''$, and are priced from about $60 to $100.

The Keystone division of Berkey Photo Inc. has come up with a series of rigid cameras that use Polaroid film. These, too, have built-in automation, eye-level viewing and focusing, and a couple of models have actual electronic flash units built into the cameras. Keystone prices start at about $35. The top of the line, with built-in rechargeable electronic flash, is priced at about $110.

The Keystone Everflash Model 850 is a rigid, instant-picture camera, featuring a built-in, rechargeable electronic flash.

10

AUTOMATIC AND SEMI-AUTOMATIC CAMERAS

When I was very young I was taken, with the rest of my elementary school class, to the General Electric research plant at Nela Park in Cleveland, Ohio, to see some of the wonderful discoveries in the world of electricity. Among the amazing things we saw was the photoelectric cell, a fascinating device which could convert light to electrical energy for the performance of various jobs. The cell was called an "electric eye," and it was attached to all sorts of machines. There are two which remain particularly strong in my memory. One was an automatic drinking fountain; by placing his head in position to drink from the fountain the drinker broke a photoelectric beam and started the water flowing. The other was a small hand-held gadget which, when aimed at an object, could measure the foot-candles of light being reflected from it. The first seemed quite practical to me, and I remember looking on the second as a sort of scientific toy.

Soon afterwards I learned that that "scientific toy" had been adapted to photography and has since become one of its greatest boons, the exposure meter. An exposure meter works this way. The light, after entering the photoelectric cell, is converted to electrical energy. This energy is used to move a very delicately mounted needle, which is visible through a little window from the outside of the meter's housing. Under the needle is a scale. This can be in foot-candles, f/stops, EV numbers, or a numerical code devised by the meter's manufacturer. By taking the number indicated by the needle and transferring it to a pair of dials elsewhere on the outside of the meter, you translate the reading into combinations of apertures and shutter speeds. Since the movement of the needle is gov-

erned by the amount of light striking the cell, any of these will give you a well-exposed picture of your subject.

There are two things you, the user, have to do. You must begin by adjusting the meter according to the sensitivity of the film you're going to be using. (This, too, is done numerically. A number indicating the film's relative sensitivity can be found somewhere within the film package.) Then you must select the shutter-speed and aperture combination (depending on such things as the amount of action in the subject, and the depth of field you desire) that suits you best; set the dials of your camera accordingly, and shoot.

Originally, the photoelectric cell was made of selenium and required no additional source of electricity. Eventually, a much more versatile cell, made of cadmium sulfide (CdS), was developed, and it requires a battery since it uses a somewhat different system. To power the cadmium sulfide cell, a special mercury battery was developed. The mercury battery is small, about the size of three dimes stacked on top of each other. In normal use, a mercury battery will last for a year or longer.

Although there were some automatic and semi-automatic cameras on the market before the cadmium sulfide cells were developed, these were quite limited. Today, automation and semi-automation are commonplace in cameras.

The semi-automatic camera requires the user to determine one of the exposure settings, usually the shutter speed. The elec-

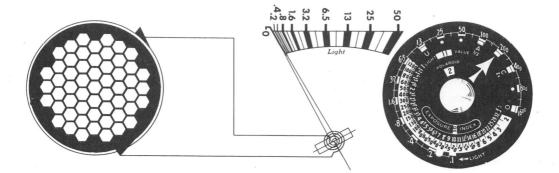

The basic principle of an exposure meter is illustrated here. Light enters the photoelectric cell, at left, is converted to electricity and travels to the movable needle. The amount of light determines the amount of electricity; the amount of electricity governs the distance the needle is moved, and this distance is measured by the scale under the needle. The distance (or amount of light) indicated is transferred to the adjustable dial and translated into shutter speeds and f/stops.

tric eye, as I prefer to call it, which has been set according to the film's sensitivity, operates the diaphragm, setting the aperture automatically. There are some cameras which operate in reverse. The user sets the aperture, and the automation determines the shutter speed electronically. Many manufacturers of such semi-automatic cameras advertise them as "fully automatic," but they are really not.

With the fully automatic electric-eye camera, you set your film's sensitivity rating on the scale, point the camera at the subject and shoot. The camera has been set, automatically, for the ideal exposure; you get the best picture possible.

With cameras based on the Instamatic system, you don't even have to worry about setting the camera for film speed. A special slot in the film cartridge automatically programs the camera for the type of film contained in the cartridge.

For the amateur who has no interest in photography, who merely wants to take an occasional snapshot without ever having to worry about such things as exposure, who wants to know only that his picture is going to "come out," this would seem to be the ideal system. Nothing could be more advantageous.

Not surprisingly, most fully automatic cameras are in the relatively lower price range, such as the GAF Memo 35 EE, which costs less than $100, and the Minolta Hi-Matic F, which costs in the neighborhood of $120. Some fully automatic subminiatures cost considerably less. Most serious photographers, the buyers of expensive equipment, prefer to be able to have a certain amount of exposure control.

Some of the Polaroid Land cameras also are fully automatic, even though the automation controls only the shutter. The system is based on a circuit of transistors, capacitors, and resistors that are powered by a 4.5-volt battery. The shutter itself is made up of two blades that work independently of each other. When you press the shutter release, the first blade moves aside, allowing light to reach the film, while the second blade is held back by an electromagnet. Meanwhile, the transistorized system measures the light, and when enough light has reached the film the current to the electromagnet is cut off, and the second blade closes behind the lens, cutting off the light. The whole operation can be completed at speeds up to $^1/_{1200}$ sec. It works with flash, as well: While the picture-taking process is going on, the camera measures

the intensity of the flash on the subject, computes the accurate exposure, and closes the shutter when enough light has entered the lens.

Some automatic cameras have some provision for disengaging or otherwise ignoring the automatic operation in favor of manual setting, should a situation so require. Others have dials that let you influence the automation by increasing the exposure to as much as double what the electric eye considers ideal, or by cutting it by as much as half the indicated exposure.

Most 35mm cameras, rangefinder or single-lens reflex, have some built-in exposure-measuring devices. A typical system for the ordinary cross-coupled metering camera would work as follows: First, as with exposure meters or automatic cameras, you set the film-sensitivity dial. Next, you select a shutter speed and set it. Then you train your camera on the subject and turn the aperture-control ring, while keeping your eye on the meter's indicator needle; when the needle is centered, or otherwise lined up with the indicator provided, your aperture should be accurate in relation to the shutter speed you have selected. You may set the aperture-control ring first, then turn the shutter-speed dial to match. To differentiate from those cameras that have no built-in exposure-measuring devices, we'll call this category "partially automatic."

Among the partially automatic cameras, most single-lens reflexes have their exposure-measuring devices behind the lenses. Since this method measures exactly the amount of light coming through the lens, it is considered the most accurate system. Among the rangefinder cameras, only the Leica M-5 and CL have behind-the-lens metering.

Some completely manual, unmetered cameras can be converted to partially automatic by the addition of specially designed exposure meters. In such a case, the exposure meter is mounted on the camera's accessory clip, and it couples to the shutter-speed dial. After adjusting for film sensitivity, you select a shutter speed and set it; then you train the camera on the subject. The exposure-meter needle points to the ideal f/stop for that film at that shutter speed, and you set the aperture ring of the camera accordingly.

The GAF Memo 35EE is a compact rangefinder-focusing camera. It features fully automatic exposure with or without its electronic flash unit.

11

OTHER CAMERAS

Since this book is directed toward the first-time camera buyer and those inexperienced in the ways of photography, I have omitted from the earlier chapters discussion of certain professional-type cameras which could not, in a practical sense, be adapted for the beginner. A novice might use a Leica or a Rolleiflex, both highly professional cameras, and get satisfactory pictures with either one without coming anywhere near the camera's potentialities for producing really fine photographs. Eventually, he might come to understand and appreciate all of the camera's many features and possibilities, and take advantage of them. But in the beginning, a Leica would be just another 35mm camera, and a Rolleiflex just another twin-lens reflex. He could run a roll of the proper size film through either one, send the film out to the drugstore for developing and "jumbo" prints, and get pictures at least as good as those he would get with his Kodak Instamatic or his Olympus electric-eye camera.

On the other hand, he might be hard put to come up with a satisfactory result from one of the extremely wide-angle cameras, such as the Hasselblad Superwide C; and he might find the whole business of changing film and focusing a little distracting with the cameras using sheet film, such as the studio view and portrait cameras, or the press-type cameras. However, I would like to touch briefly on these and a few others that didn't fit into the earlier categories.

VIEW AND PRESS CAMERAS

The big, imposing view cameras one sees in photo studios are not the complicated and mysterious machines the photographers, partially concealed by their black fo-

cusing cloths, would have one believe. Actually, these are first-generation descendents of the first *camera obscura*. The major refinement is from the use of glass plates to sheet film on a transparent plastic base.

A view camera consists, mostly, of a light-proof bellows, on the front of which is a lens and shutter, and behind which is a groundglass screen. Either or both the front (lens) panel and the back (ground-glass) panel are mounted on an adjustable track. The image entering the lens is projected, upside-down and backwards, on the groundglass. Focusing is accomplished by racking one or both of the movable panels back or forth until the image on the groundglass is sharp. Then a lightproof film holder is slid between the groundglass and the bellows. Once the holder is in place, a black slide covering the film is removed, and the single sheet of film, occupying the position the groundglass had during focusing, is exposed. The photographer must reinsert the slide before removing the film holder. Most holders are two-sided, so the photographer can, by turning his holder over and sliding it back into the camera, take a second picture. These pictures are taken on individual sheets of film, which must be loaded by the user into the holders in the dark, and removed for development in the same way.

The front and rear panels of most of today's view cameras are adjustable in that they can be raised, turned, or tilted, allow-

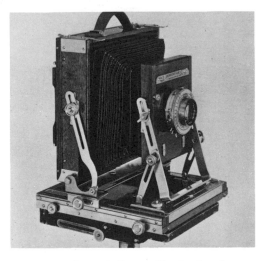

The view camera is the most basic of professional cameras. The collapsible bellows permits lens panel to move back and forth for focusing. Both front and back panels can be tilted forward, backward, and from side to side for correction or creation of image distortion.

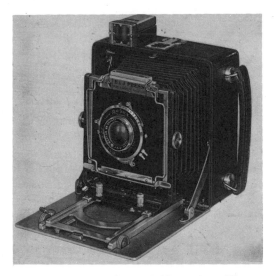

The press camera is a portable version of the view camera. It can be handheld in operation. Most have built-in flash synchronization. Accessories include coupled rangefinders and optical viewfinders.

ing the photographer to make certain compensations for distortion that might result from the subject's size or position.

View cameras come in several sizes, designated for the size of film they use, 4″ × 5″, 5″ × 7″, 8″ × 10″, and the like.

The black cloth, by the way, is used to keep stray light and glare off the groundglass during the focusing.

Press cameras, such as the well-known Speed Graphic (long a badge of the professional newspaper cameraman), are adaptations of view cameras. The press camera is more portable, since it folds up for easier carrying. It has a rangefinder and separate viewfinder, in addition to the groundglass, to make focusing and viewing faster. And it has a device (usually a strap) to permit its use as a hand-held camera when the rangefinder and viewfinder are employed. A view camera must be used on a tripod, since the camera's position must be maintained during the lapse between viewing and focus-

ing, and (after the film is inserted and the slide pulled) the actual taking of the picture. Most press cameras, too, have built-in, or provisions for, flash synchronization. View cameras, for the most part, do not. Some commercial studios, however, have replaced their view camera shutters for those synchronized for studio-type electronic flash.

Press cameras come in two sizes, also designated by the sizes of the film they use, 2¼″ × 3¼″, and 4″ × 5″.

Accessory backs are available for some press cameras. These may be purchased for adapting the cameras to 120-size roll film, regular Polaroid roll film, or 4″ × 5″ Polaroid sheet film; and special holders are available for use with film pack (a single pack containing 12 sheets of film packed by the manufacturer in a metal box), or a special multiple-sheet holder (into which the photographer can load six sheets of regular film).

ESPECIALLY WIDE-ANGLE CAMERAS

The so-called "normal" lens for most cameras has an angle of view of approximately 46 degrees. This means that the lens will take in an area within a 46-degree angle from the center of the lens. With lens interchangeability, the photographer can increase this angle by removing the normal lens and replacing it with a wide-angle lens; or by adding a wide-angle element to his normal lens. There are, however, limits to how far you can increase this angle without having to adjust the size of the camera body itself. Since we can't change the camera bodies, special bodies have been designed to accommodate unusually wide-angle lenses. Usually, the body is designed to accommodate one specific lens size, and interchangeability is then not practical, nor

is it offered. These cameras are simply wide-angle cameras. Such a camera is the Hasselblad Superwide C, a 120-size roll film camera with an image angle of 90 degrees.

Many professionals find it practical to own these cameras for certain special jobs. For instance, they can be used in very small places, because even up close a 90-degree lens angle will include a good deal of subject. They can be used for architectural work because the large amount included in the picture makes it convenient to use such a camera to photograph an extremely large structure. As we explained previously, the wider the lens' angle, the greater its depth of field. An extremely wide-angle lens is a boon in a situation requiring extreme depth of field. Also, the great depth of field makes such a camera convenient for the journalist who hasn't time for fine focusing.

Especially wide-angle cameras are designed for unusually wide angles of view. Hasselblad Superwide C has an angle of 90 degrees, compared with the 46-degree angle of the normal camera.

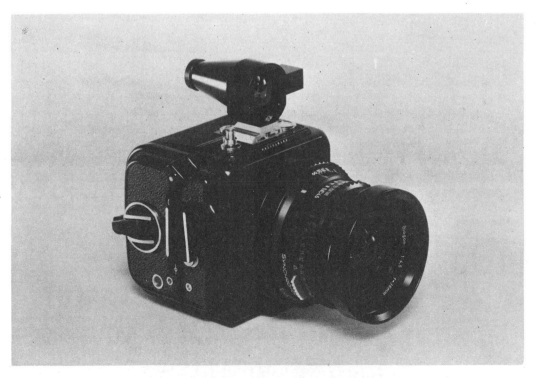

SEQUENCE CAMERAS

For some photographers, the rapid film-advance levers on most cameras are just not fast enough or are too much trouble. They want to be able to take one picture after another, in rapid sequence, without having to worry about advancing the film. There are two aids for them. One is the addition of the electric motor drive, such as is available for the Nikon F2 and F. This is just what the name implies, a small motor which attaches to the camera and advances the film, automatically, after each shot. It can be used for single shots, or in bursts of two or more, continuously, so that an entire roll of film can be exposed with one touch of the shutter release. The second solution is found in the power-operated cameras, such as the Robot, which comes in several models. With the Robot you wind a spring, which powers the automatic film transport. Each winding of the spring lets you shoot as many as 18 pictures, singly, or in sequence with a single squeezing of the release button, at speeds as fast as eight pictures a second.

The Topcon Auto Winder (above) has a battery-operated motor, the Robot camera (below) has a wind-up spring motor.

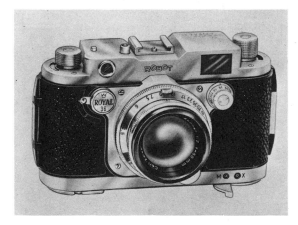

A sequence camera or a regular camera with motor added lets you shoot without having to take the camera from your eye. The pictures on the facing page capture sequences that are almost like movie footage.

60

BUT MAKE UP YOUR OWN MIND

Even though the camera types listed here fall into a special section, it is not entirely reasonable to rule them out completely as starting cameras for even novice photographers. It's true, they are, from the standpoint of this book, special-purpose cameras, but it's quite possible that some beginners will be interested in "special purpose" photography. Don't be restricted by labels; let your choice of camera suit you. A person who wants to carry a camera in his pocket at all times might naturally be steered toward the subminiatures. But suppose he is dissatisfied with the limitations of these cameras. Is there any reason why he shouldn't buy a small 35mm camera, such as the Olympus 35 RC or the Leica CL, provided price is not a consideration? Of course not. The 35mm is substantially heavier than a subminiature, but the photographer would gain in other respects. The same thing applies here. If you feel you want the quality of a big negative, or the control of groundglass viewing and focusing with a movable lens board that will al-

low you to eliminate certain distortions in, for instance, landscape photography, you can get all this, plus portability, in a press or lightweight view camera, although the latter will always require the use of a tripod. The entire outfit will be heavy, but if it suits your interests, why not? Or perhaps you're interested only in pictures of children, and your experience has been that the best expression usually comes through just after you've taken a picture and is gone by the time you're ready for the next one. Maybe sports photography is the major attraction for you, and you don't want to take the camera from your eye for fear of missing an exciting moment. Either of these special interests could be satisfied with a sequence camera, or you might want to invest in one of the 35mm cameras that offers motor drive as an optional accessory.

There's an old cliché about how the amateur photographer has one advantage over the professional: He doesn't have to please anyone but himself. Trite or not, it's true, and it's something to keep in mind when you select your camera, and subsequently, when you take your pictures.

12

WHAT ABOUT ACCESSORIES?

Among photographers, there are those who own accessories for their cameras with an aggregate value of many times the purchase price of the cameras themselves. At the other extreme are those purists who wouldn't use an accessory, even so much as a sunshade, under any circumstances; who feel that the basic camera is the tool and getting it to accomplish any photographic task is the challenge.

In between lies the majority of photographers, amateur and professional. They look to accessories for their strict functional value; they'll buy a $2 filter or a $200 lens (with a certain amount of cogitation) if they think the extra purchase will serve to enhance their photography, make picture taking easier, or help them increase their scope and money-making potentialities.

Often I've been asked by people contemplating buying cameras, "If I buy one, how much will I have to spend on accessories?" The answer, of course, is, "Nothing." You don't have to buy anything but a camera and film in order to take pictures. However, there are many accessories that will help you, some more than others. One of the most important, as far as I'm concerned, is an exposure meter. This, naturally, doesn't apply to owners of box cameras or those with very limited adjustment. But if you buy a camera that will take pictures under a great variety of conditions, it would seem, provided your camera does not have a built-in meter, that an exposure meter would represent a small investment, in return for which you'll be able to get the most out of your camera.

EXPOSURE METERS

Photoelectric exposure meters, you'll find, come in a full range of prices, and there's a reason for this. The price of a meter usually reflects its versatility and ability to make readings under extreme conditions. For instance, there's a meter that gives readings down to $1/500,000$ sec. and naturally enough, costs a great deal of money. Such a meter would be of immeasurable value in certain specialized types of photography but would be considered a bit extravagant for the owner of a camera whose shutter went no faster than $1/500$ sec.

In buying a meter you should look for one that will operate within the full limits of your camera and be able to accommodate all the films you are likely to use. You might also consider the question of size and carrying convenience. Some of the most versatile meters are quite bulky, but many photographers will put up with this for the sake of their functional conveniences. On the other hand, there are, today, meters that are so small as to seem relatively weightless. Some of the miniature ones also have provisions for fitting them to your camera's accessory clip, adding to their portability.

FILTERS

In discussing filters for black-and-white photography, we must say a few words about the color of light. Pure white light, as we see it, is not really white. It is a combination of all the colors of the spectrum, which is made up of a continuously varying band of color ranging from violet to red. We see a

Wide-angle lens lets you compose broadly without moving back. This photo was taken from a car window on a back road in Jamaica. By making use of accessory lenses, I never had to leave the driver's seat.

A telephoto lens lets you move in close to the subject and eliminate unwanted foreground and side elements for tight composition. Its short depth of field adds extra control by softening or practically eliminating the background.

To relate the subject to its background, as in the case of this giraffe (taken on photographic safari in Kenya), I lowered the camera to accentuate the animal's height. I then waited until his position against the clouds was right for the picture I wanted.

(Above) This farmer/general-store keeper (on the Greek island of Corfu) thought my interest was confined to his rooster, of whom he was obviously quite proud. Therefore, I was able to capture this candid shot of them both. (Right) Lying on the ground at a Mexican market, the jugs became a study in patterns and colors by moving in on them to the point where only the patterns necessary to make the picture remained in my viewfinder.

(Left) When shooting color slides, you have to compose and crop right in the camera's viewfinder. By moving in close to the parrots (Busch Gardens, Tampa, Fla.), I was able to eliminate such distracting elements as buildings, fences, and other visitors who had gathered to watch and photograph the birds. (Below) Familiarity with your camera enables you to move quickly when a photographic opportunity presents itself, as happened with this trio of Peruvian youngsters who, for a moment, made a natural travel picture.

For this Peruvian Indian mother and child, I switched to a telephoto lens to achieve tight composition. The short depth of field of my lens eliminated all background distractions by throwing them out of focus.

By darkening blue sky slightly, a medium-yellow
filter accentuated the clouds.

certain color in an object because it is actually absorbing all the colors of the spectrum but the one we see, which it reflects. (The complete absence of color is black.)

Filters are pieces of colored glass or gelatin which absorb some colors and permit others to pass through them. Specifically, a filter will absorb all colors except its own. You can see this happen when you place a piece of colored glass between a light source and a piece of white paper. The light passing through the glass and striking the paper will be the same color as the glass itself. This principle can be employed very effectively in photography. If, for instance,

you cover your lens with a yellow filter, all light but yellow will be filtered out, leaving only those objects with yellow in them to register on your film. However, there is no "pure" color. In fact, every bright color has some yellow in it. So, these objects will register on your film in black and white, although their tonal relationships will be altered to some extent.

Yellow happens to be the most popular of the filters, and its use is most notable for its removal of the violet and blue end of the spectrum in photographs which include the sky. The result is, of course, a darkening of the sky. Its usual purpose is to bring out, by

65

contrast, the whiteness of the clouds.

Yellow is at a middle point on the spectrum. Adding increasing amounts of red to it brings it, gradually, toward the red end of the spectrum; just as adding increasing amounts of blue takes it through green to the violet end of the spectrum. By darkening the yellow (through the addition of red) we find that we can eliminate more and more of the other end of the spectrum, and, in photographs of the sky, remove more and more of the blue from the picture. Thus, an orange filter will make the sky appear quite dark in your photograph; a red filter makes it so dark that red filters sometimes are used to simulate night photographs.

A green filter will make green objects appear lighter, even white, in your photograph. This is used most effectively in pictures that include foliage which might otherwise go extremely dark, thereby losing detail in the final print.

You must, of course, consider the other objects in a photograph when electing to use a filter, and the filter's effect on them. This applies to people in particular. A yellow filter tends to lighten skin tones, giving it an almost translucent quality, while a light green filter adds tone to skin. Red is one filter which should never be used to photograph people, since it will whiten skin and practically white out any color in lips.

Color photography calls for an entirely different type of filter from that used in black-and-white work. If you were to use a regular yellow, red, green, or other filter with color film your picture would have an over-all cast of the same color as the filter.

In color photography there are light balancing filters and corrective filters. The light balancing filters are used when you have daylight-type film in your camera, but want to use it indoors, by artificial light. The proper filter will balance the quality of the light with your film. The same applies, of course, if you should have indoor film in the camera and want to use it by daylight.

The corrective filter which will be of most use to the amateur is the skylight, or haze, filter. This filter reduces the over-all bluishness of a picture taken on a hazy day by adding a touch of warmer, brownish, color.

TRIPODS

A tripod is a very useful accessory, and one which will come in quite handy for indoor pictures under low-lighting conditions, when the use of slow shutter speeds becomes necessary. Even holding a camera steady at a speed slower than $1/50$ sec. is difficult, and not particularly recommended, but holding one steady at a speed slower than $1/25$ sec. is considered almost impossible, except for the most experienced photographers. When taking pictures at slow shutter speeds, therefore, the use of a tripod (or some other object on which you can steady the camera) is highly recommended.

Your choice of a tripod should depend, somewhat, on your camera. The heavier the camera, the more substantial should be the tripod. Select one that will hold your camera steady, but which will be light enough to carry around outdoors, should it be required.

Tripods have telescoping legs, which can be adjusted to the height required for your picture, and which can be collapsed completely to facilitate carrying. Make sure the one you buy folds up to a small enough size to suit your purposes.

Once you have your camera on a tripod you might want to adjust its angle. For this purpose, some tripods have adjustable tops. If your tripod doesn't have one, you can add one to it. This adjustable top is called a *pan head*.

While using your camera on a tripod, it's still possible to shake it by the pressure of your finger on the shutter release. This can be avoided with the use of a cable release, a length of cable containing a movable flexible rod. One end of the cable release is threaded, to screw into a special socket on the camera. On the other end is a plunger

which, when pressed, moves the cable's rod against a release mechanism inside the camera, activating the shutter, allowing you to release the shutter without touching the camera.

RANGEFINDERS

If your camera requires focusing, but does not have a built-in rangefinder, it's possible to buy one as an accessory. Although these accessory rangefinders do not couple to your lens, they serve to good purpose. A separate rangefinder is constructed, on the same lines as the built-in type, of two prisms and an adjustment dial that brings their twin images together. By adjusting the dial until the two images seen through the rangefinder window are combined, you set the distance between you and the subject on a distance scale. A glance at this scale tells you how to set the distance scale on your camera.

Portable tripod allowed me to photograph this candle-lit Mexican cafe scene at $1/8$ sec.

GADGET BAGS

Your need for this accessory will depend on the number of other accessories you buy. Gadget bags are made in many sizes, of leather and plastic, and it's quite likely there's one to suit your needs and the price you're willing to pay.

In buying a gadget bag you should consider several factors. The most important, of course, is its size. Is it large enough to hold everything you'll want to carry in it without being so big that it becomes a burden? If it does not have adjustable compartments, is it sectioned to suit the individual pieces of your outfits? Are there enough small pockets to carry your filters and other small accessories, to keep them from getting lost in the bottom of the bag? Nobody wants to have to unload an entire gadget bag every time he goes to change a filter. If you intend to carry a tripod with you most of the time, you might look for a gadget bag with a pair of straps for holding a tripod beneath it.

Above all, be sure you buy a gadget bag with a shoulder strap. Carrying it by the shoulder strap allows you to keep both hands free for taking pictures.

OTHER ACCESSORIES

There are many other accessories you can buy to make photography easier or more fun. Such things as underwater housings, close-up attachments, copying equipment, and the like, will depend on your individual experience and how deeply you get into photography. There are, though, a few small things you probably won't want to do without. If you buy filters, chances are you'll need an adapter ring. This is a two-part ring. One side of it fits onto your lens. The filters go between the two sections,

and the sections are screwed together, one into the other. A sunshade, to keep stray light from entering your lens, is extremely useful for outdoor photography, particularly when you take pictures with the sun anywhere but behind your back.

One accessory I consider a must is a small blower. You can find one of these in practically any camera store. If your camera store doesn't carry them, you can buy one in most drug stores, where they're called "baby ear syringes." Dust creates many problems for the photographer. It can scratch the delicate emulsion of the film; and it can, if allowed to accumulate, interfere with the normal action of the shutter. Dust on the lens interferes with the light going through it and on your finished negatives will result in white spots on your print. Therefore, I always manage to have one of these small blowers in my gadget bag. I use it on the inside of my camera whenever I change film, as well as to keep my lens free from foreign material.

POLAROID ACCESSORIES

Most accessories come in varieties of sizes, or can be adapted so that they may be used with most cameras. But since the Polaroid Land system is an individual system, the accessories available for conventional cameras will not, normally, fit Polaroid cameras. For that reason some people who might otherwise be interested in this system would be inclined to stay away, fearing that they would not enjoy the full freedom of choice of accessories they might ordinarily have. This is far from the truth. Polaroid makes and sells a complete line of accessories, including filters, close-up attachments, timers, meters, flash holders, and even gadget bags with compartments for holding these along with the cameras.

(Above) Much of the foreground detail is lost due to strong backlighting.
(Below) Flash is useful outdoors to fill in the facial and foreground shadows.

13

ACCESSORY LIGHTING

Photography deals, by its very nature and its definition, with light. The word, "photography," means *to record with light.* And light is the photographer's most important tool. In today's photography, increased film sensitivity and enlarged lens apertures have made it possible to take pictures under very adverse lighting conditions, with no supplementary light added to the scene. But although this is possible, it's not always desirable. For one thing, the larger the lens aperture, the shorter the depth of field within a given picture; and the more sensitive the film, the less image quality in the picture (as we shall discuss in the chapter on film). Most photographers find themselves in situations, from time to time, requiring the addition of some light, in order to take a satisfactory picture. Most photographers own some supplementary lighting equipment, either for carrying with them or for use in the studio. The two basic types of supplementary lighting are *flash* and *flood.*

FLASH

There are two types of flash, bulb (or cube) and electronic. A flashbulb contains a material which, when ignited, burns at such intensity (and brightness) that it burns itself out with one use. But during the moment of its peak of brightness it gives off enough light to illuminate a substantial area for photography. The electrical power that ignites the bulb comes from dry-cell batteries within the flash unit.

For electronic flash the bulb, called a *tube*, is almost a permanent piece of equipment. Each electronic flashtube can be used for thousands of pictures. Its light, too, is bright enough to take pictures by, but the flash is of such short duration that it

does not get hot. Most flashtubes light at speeds of $1/2000$ sec. or faster.

There are several things to consider when deciding whether to buy bulb or electronic flash. First of all, does your camera have the necessary synchronization? A camera must provide for the shutter to be fully open at the time the flash is at its brightest, or *peak,* at one or more shutter speeds. Most cameras are synched for bulb flash. Even among the simplest box cameras are those which provide a contact and the necessary synchronization for flashcubes or a flashgun manufactured specifically to accommodate them, or have flash reflectors built right into them. Secondly, how much will you use the flash equipment you buy? Bulb-flash equipment is relatively cheap, but each time you use it requires buying another bulb. Electronic flash, on the other hand, is comparatively expensive (though getting less so), but it pays for itself in the long run, since one tube lasts for thousands of flashes.

Consider, too, portability. All but the large studio-type units are considered portable, but there's a great difference in weight and size. Today, because many of them use tiny BC circuits, there are bulb-flash units that weigh only a few ounces and fold up so small they can fit in your pocket. An electronic flash unit, on the other hand, requires a good deal more power. Electronic flash units can be powered by regular household voltage, but to make them portable requires batteries. Today's

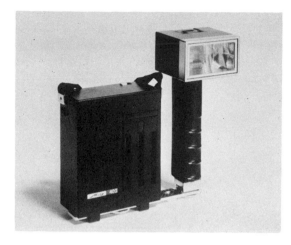

(Above) Metz Mecablitz 402 electronic flash unit.

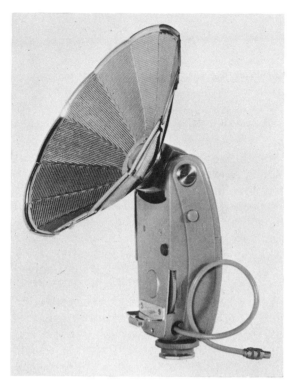

(Above) Some flash units have collapsible reflectors. Entire unit folds up and can be carried in your pocket.

(Left) Regular flash holder contains bulb within a polished reflector. Batteries are inside the base of the unit.

electronic flash units are also getting smaller and lighter, and the smallest are as portable and light as the smallest bulb units. More powerful units, however, require separate wet or dry-cell battery packs, which you must either hang on your shoulder, fix to your belt, or otherwise accommodate. This adds up to a minimum of an extra pound, usually more, to carry around with you.

If your camera has built-in flash or accommodates only the one provided by the manufacturer, you have little choice. However, if you have freedom to select your own flash unit, consider, besides price and portability, whether it has an adjustable reflector, or whether it can be used off the camera—it would be attached, in this case, by an electric cord. If you can adjust the position of your reflector or use the flash off camera, you'll find you can do more with flash than just provide simple, harsh illumination. You can place your flashgun in a position to highlight your choice of specific area of your picture; or you can direct it toward the ceiling or a wall and bounce its light, thereby providing a soft, even illumination; or by being able to change its position, you can use it outdoors, to fill in the unflattering shadows of a sun-lit picture.

FLOODS

You'd think that with the advent of electronic flash, photographic floodlighting would go out of existence, since floods' advantage of using one bulb indefinitely would have been negated. But this is hardly the case. Many amateurs continue to use floods and spots (which we won't go into in this book, since it involves some advanced technique of its own), as do many professionals, and it's likely you'll find some floodlighting equipment in the majority of studios. The reason for this lies in flood-lighting's great advantage: You can see the light on the subject before making your exposure. To many photographers concerned with the exact placement of light for absolute control of the shadow and highlight areas of a photograph, this is indeed important. With flash, although you have a certain amount of control insofar as direction and placement are concerned, you have no exact idea of where the actual highlights and shadows will fall. Flood-lights also have the advantage of being able to light large areas.

Your floodlight outfit can be quite inexpensive and simple. You might buy stands, which are collapsible and lightweight, or you might choose to use your floods on clamps, which can be attached to the backs of chairs, the sides of doors, regular lighting fixtures, and so on. You might buy floodlight reflectors, which you would use with bare flood lamps or even high-wattage household bulbs, or you might decide on the (more expensive) *reflector floods,* which have silver-coated inner surfaces and serve to direct the light in a beam similar to that thrown by the reflectors.

Bare floodlight bulbs are sold in two sizes, No. 1 (250 watts) and No. 2 (500 watts). Reflector floods also are sold according to two designations, RFL2 (500 watts) and RSP2 (500 watts), which has its inside coating set for a narrower beam than that thrown by the RFL2, and comes closer to being a spotlight than a flood.

Floodlights, like flash, can be used either directly or bounced. The bounced flood is, of course, softer, and comes closer to simulating natural illumination. For direct use, you should have at least two lights, one for the main, or modeling, light, and the second (either a weaker bulb or one farther from the subject) to soften the harsh shadows caused by the main light. A third light is very useful in portraiture, for lighting a subject's hair, for balancing the light in a full-length portrait, or for lighting other parts of the scene, such as background objects.

If you intend to use your floods with color film, make sure, when you buy them, that the bulbs are balanced for color.

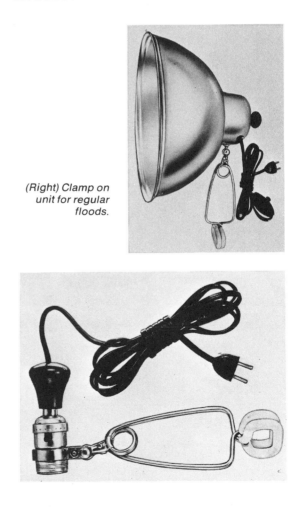

(Right) Clamp on unit for regular floods.

(Above) Clamp on unit for reflector floods.

Folded handkerchief was placed over electronic flash unit to soften light for this portrait.

Single flash was held to far right for strong contrasty effect required for this shot.

14

FILM

Throughout this book we have made various direct and indirect references to film. It's time, now, to take a closer look at this subject, and to answer certain basic questions which occur to most people when they first become interested in photography.

What is film?

Why is there more than one kind for each camera size?

How do you decide which to buy?

How can you make it serve you to the best advantage?

BLACK-AND-WHITE FILM

The first question can be answered quite simply. Film, the basic black-and-white we know so well, is a sheet of transparent, flexible plastic, about .003-inch thick, covered on one side with a layer of light-sensitive photographic emulsion. The chief ingredient of the emulsion is a compound of *silver bromide* crystals.

Here's what happens when the light strikes the film. An invisible change takes place in those crystals struck by light. When the film is placed into a (chemical) developer solution, those crystals turn black. After development for a predetermined time (depending on temperature of the solution, type of film, and effect desired) the film is removed from the developer, rinsed, or placed in a *stop bath,* to stop the action of the developer, and placed into another solution, the *fixer.* The fixer dissolves all the silver bromide crystals which were not exposed to light. The result is a negative image on a piece of transparent plastic; negative, in that the brightest parts of the photographed subject, those which reflected the most light into the camera, are represented as black. Those which reflected no light are clear. In between areas, the middle tones, appear as various shades of gray, depending on how dense an area of crystals has been exposed and developed.

In reply to the second question, about the number and kinds of film in each size, we must point out, first, that there are two important requirements the photographer makes of film—quality and sensitivity. By film quality, we mean the sharpness of image; the absence of apparent *grain* (the crystals), even in a greatly enlarged print; and *definition*, the over-all clarity of detail. Some films have more (sharper, in this case) quality than others. By sensitivity, we refer to the amount of light required to record an image on the film. Some films will work only in the brightest light, while other films can be used in situations so dimly lighted that the photographer has trouble focusing the camera.

Although there are photographers who have a strong preference for large amounts of grain in their pictures, the great majority seeks to keep grain at a minimum while enjoying the most *speed* or sensitivity. Since we know that we can achieve remarkably fine grain in film manufacture, and since we know that some of today's films have so much speed they amaze even the most blasé professionals, why, one might ask, don't they simply manufacture one standard film, with the least amount of grain and the maximum speed. This, unfortunately, is impossible, because in order to increase

film sensitivity it is necessary to increase the size of the silver bromide crystals proportionately. The result is that the fastest films must, by their very nature, have the largest, most apparent grain.

So, how do you decide which to buy?

Film speed is rated according to standards set up by the American National Standards Institute, formerly American Standards Association. (In other countries, other types of ratings are used.) The American Standards, or ASA, ratings of film speeds run on a graduated scale, with the numbers increasing in size as the film increases in sensitivity. The high-speed films (with the exception of Polaroid, which represents a different system) have extremely large amounts of apparent grain.

So you can't have both sharpness and speed. You must, then, compromise, by selecting a film which gives you enough speed and by settling for the grain that goes along with it. The ideal way to choose, therefore, is to select the film which is just fast enough (with a slight amount of margin) for the particular type of shooting you plan to do. Keep in mind, though, that supplementary lighting (flash or flood) can help you keep film speed and grain down.

To make film serve you best you must first find out how much speed you'll need. For most of us, this comes with practice. But it's easy to get started by consulting the instruction sheet which accompanies each roll of film. This sheet tells you recommended shutter speeds and *f*/stops to use with the particular film under various lighting conditions. Check to see if these settings are possible on your camera.

The instruction sheet's recommendations will work, to some extent, but no such guide could come anywhere near being perfect, since one man's hazy day might be a full *f*/stop away from another's; one man's room light might be in the 60-watt neighborhood, as compared to 100 or 150 watts for another; so the manufacturers, in putting out these recommendations, must rely on the fact that film has a certain amount of latitude. You might want to do better; you might want to aim for perfection —not to mention a bit of control over which areas get the ideal exposure and which get taken care of by the latitude, or go over or under. For this you'll need an exposure meter. And again, the instruction sheet will come to your aid. On each instruction sheet you'll find the ASA rating of the particular film it accompanies. This rating, also called the *exposure index,* is your guide in setting your meter.

Film, generally, is broken up into three classes: slow, medium, and fast. Unless you take pictures only outdoors in bright sunlight you'll find, quite likely, that you'll settle, most of the time, for a medium-speed film with moderate grain. Box cameras and the slightly more complex ones are fixed to give the best results outdoors, under bright sunlight, with slow film. However, you'll find the brilliance of uncovered overhead sun creates harsh shadows and unflattering contrasts in your pictures; and sooner or later you're likely to agree that the most pleasant pictures are taken when there's a slight haze in the sky or, when the sun shines its most brilliant, in open shade. Because of the reduction of the light's intensity, you'll want to increase your film's sensitivity, and here again you'll more than likely settle for a medium-speed film. If you take your box camera indoors, try one of the fast films. You'll be amazed at the results.

(Right) Slow film produces an almost grainless result and strong contrast.

Here is a list of the most readily available black-and-white films in the United States, classified according to the three usual classes, slow, medium and fast and a fourth class, ultra-fast.

Slow

Ilford Pan F; Kodak Panatomic-X; Polaroid Type 55P/N

Medium

Fuji Neopan SSS; GAF 125; Ilford FP-4; Kodak Plus-X Pan

Fast

Ilford HP-4; Kodak Tri-X Pan; Polaroid Type 105

Ultra-fast

Kodak Royal-X Pan; Kodak 2475; Polaroid Type 107

COLOR FILM

Color photography, which still flabbergasts some people, is, as a matter of fact, an extension of the old painter's principle (also taught in elementary school art classes) that all colors can be made from mixing the three primary colors—yellow, red, and blue.

Color film begins, like black-and-white film, with a surface of clear, flexible plastic. However, instead of putting one layer of silver bromide emulsion onto it, as with black-and-white film, the manufacturers put three layers of emulsion onto it. Each of these layers is filtered so that it is sensitive to only one of the three primary colors. On positive or *reversal* color film, the kind that gives you transparencies or slides, such as Kodachrome, the layers are sensitive to yellow, a shade of blue called *cyan,* and a shade of red called *magenta.* The film is developed as three layers of black-and-white emulsion, but about mid-way in the development a chemical is introduced that forms a dye in each of these three layers, according to each layer's individual sensitivity. So all the exposed silver in the top layer is dyed yellow; the second layer, magenta, and the bottom layer, cyan. Of course, since most colors contain mixtures of these three colors, many parts of the picture will have some of each layer; others will have some of only two, and the pure colors will be found restricted to their individual layers of emulsion. When light is projected through this film (or when it's viewed against a light surface) the three layers seem to mix their colors and produce a picture with all the shades and tones of the original subject. (The complete absence of color appears as white; a combination of all three becomes black.)

Negative color film, such as Kodacolor, follows much the same principle, with the exception that the colors are reversed, the yellow of the subject registers as cyan, and so on, with much the same effect as negative black-and-white. The colors, then, are re-reversed in the printing. You can, in fact, make black-and-white prints, in addition to color, from a color negative.

It's possible, also, to have slides or transparencies in addition to prints made from your color negatives at a small cost; and for an equally small cost you can have color negatives made from your slides and transparencies. Most large color film processors now offer these services.

A peculiarity of light brings forth a point to consider in selecting your color film. Light sources have different color qualities. For instance, daylight has a slight blue tone, while tungsten bulbs give off a yellowish light. Positive color film is, therefore, separated into indoor and outdoor types. Negative color film, on the other hand, requires only one film type for all illumination, because the slight differences, readily apparent in a slide as yellow or blue casts, are compensated for in the printing. Of course, filters can be used on the camera to balance the light under which you're shooting for the type of film you have in the camera.

Medium-speed, all-purpose film keeps you ready for unexpected photographic opportunities. It lets you control depth of field and requires practically no sacrifice of grain sharpness.

Color films fall into three speed classes. Of those readily available in this country, all the negative films (for prints) are in the medium-speed category. The reversal films (for slides) are divided as follows:

Slow

Kodachrome 25; Kodachrome II, Type A (indoor)

Medium

Agfachrome 64; Fujichrome R-100; GAF 64 Color Slide Film; Kodak Ektachrome-X; Kodachrome 64

Fast

GAF 200 and GAF 500 Color Slide Films; Kodak High Speed Ektachrome

Negative

Agfacolor CNS; GAF Color Print Film; Kodacolor II

Fast black-and-white film lets you shoot by existing illumination in low-light situations, and it allows hand-held speeds for stage lighting without requiring wide-open apertures.

15

YOU CAN TAKE
GOOD PICTURES

The title of this chapter does not imply that by reading it (the chapter) you will become a professional, or even an accomplished, photographer. I start the chapter with such a negative statement because I want to lead up to one important point: *Taking pictures is the best way to learn to take good pictures.* After selecting a camera and getting familiar with its various features and controls, you must establish a relationship with it in which the operation of the camera itself becomes almost second nature to you. This familiarity is bred by practicing, by taking roll after roll of pictures, until the mechanical aspects of operating the camera can be accomplished, when a picture situation arises, without a second thought. Once this point is reached you can start worrying about creativity.

There are certain typical technical errors amateurs make. Some of these faults are so obvious that you might find it difficult to imagine how people manage to commit them, and yet they do, in roll after roll, all over the country. Take camera movement, for instance. It's a well-bandied-about fact that you should not try to handhold a camera at shutter speeds slower than $^1/_{50}$ sec. and that you *cannot* hold it still, unless you have nerves of steel or many moons of practice, at shutter speeds slower than $^1/_{25}$ sec. How do you avoid this? Should you pass up a picture-taking opportunity rather than risk camera movement? Not at all. If you have an adjustable diaphragm on your camera the answer is, of course, open the aperture enough to compensate for speeding up shutter speeds. The ratio of compensation is very simple—one to one. For each step on the scale that you increase your speed open the aperture one step on its scale, or one f/stop. But suppose you can't open it any wider, maybe it's all the way open, or for depth-of-field purposes you have to stop down. Then don't try to handhold it. Your first choice is to use a tripod. If you haven't one with you, set the camera on something, a bench, a fence, a post, a mailbox, or any fairly solid prop. If you can't do that conveniently, then brace yourself, by leaning back against a wall or fence, press your elbows to your sides, take a deep breath and hold it for the moment it takes you to shoot the picture.

Learn to see everything that's in your viewfinder, and you'll avoid another very common error, the awkward chopping off of heads, arms, or legs. You don't of course have to include arms and legs in every picture, but you should, whenever possible, avoid cropping a subject across any visible flesh. Crop people within clothing areas.

CONCENTRATE ON SIMPLICITY

Aside from technical proficiency, there is one specific guide to follow in seeking picture quality in your photographs—simplicity. Probably the lack of simplicity is the one major factor that makes amateur snapshots look like amateur snapshots. Naturally, we realize that in taking a picture you can't just remove your subject from its surroundings in order to achieve an effect of simplicity. But you can arrange your subject, your camera position, or your camera angle in such a manner as to cause the subject to stand out as a unit within the picture,

Keep it simple. Position the camera to eliminate unwanted subject distractions.

with everything else in the photograph related to it in a complementary manner. Sometimes this can be accomplished by simply positioning the subject so that it will contrast with its surroundings. You can take advantage of the selective depth-of-field control of your camera to set off the subject. Or you can create a frame around the subject, thereby giving it the necessary visual impact. These things can be accomplished in the most cluttered surroundings. You arrive at simplicity by thinking a little before you even raise your camera to your eye.

BE THE CAMERA'S MASTER

You must, somehow or other, become the master of your camera and not its slave. According to my definition, a person who is his camera's slave will, upon deciding to take a picture, point the camera at the subject, making sure the subject is within the viewfinder, and press the button. A person who is his camera's master will make the

camera work for him, serve as his tool in making photography, to some extent, a creative process. He will consider the subject and decide how he wants it to fit into the dimensions of the final print; he will consider the background and use it only to enhance the picture, relating it to the other levels of the picture, foreground and middleground, if any, and use the latter two for similar purposes. This sounds, I suppose, as if I'm recommending that you spend so much time planning the picture that the subject might walk away and the sun might set before you get around to the fraction of a second involved in the opening and closing of the shutter. On the contrary, this pre-planning and pre-considering will become, with practice, a snap-judgment affair, and you'll find yourself doing it automatically during the few seconds involved in getting the camera into shooting position. Just the slightest change of your position, to the side or up or down, will change the entire relationship of any one level of the picture to any other.

Be the camera's master so you can work fast—shoot when the subject is ready.

Be aware of composition, and control it by camera angle and selective viewing.

SCENERY

Don't be fooled by landscapes and build-ings. They would appear, since they don't seem to struggle or object, to be the easiest things in the world to shoot. Pictures of this type require the most careful planning, and since, fortunately, they don't move, you can take all the time you need to come up with a picture worth putting into your album.

Most landscapes are shot completely haphazardly, with the result that they be-come pretty meaningless in the finished prints. Remember, the camera does not see as your eye sees; and remember, also, that the final print is not going to be life-sized. This means that you must manipulate the shot if you don't want the beautiful land-scape you saw on your vacation to become just a couple of meaningless gray horizon-tal lines whose only function, as a picture, is to touch off a long explanation, on your part, about how beautiful the scene really was, but how impossible it was to get a de-cent picture of it.

How, then, do you get a decent picture of the hills on the horizon? By simply relating it to other elements. A tree, a piece of farm machinery, a building, or even a person in the foreground will do it. But you don't want the foreground to dominate the pic-ture, so you do one of two things, either throw it out of focus or underexpose it so

that the foreground becomes little more than a silhouette for the purpose of empha-sizing that part of the picture you want to show off.

When you take a picture of a building you'll find, unless your camera is absolutely level, that the building's lines seem to con-verge, giving you what amounts to a false picture. You'd be better off shooting only a portion of the building, unless you desire the effect created by the converging lines. The only other solution, unless you're using a camera with the tilts and swings of a view camera, is to keep the camera level. Often, this will mean stepping back or using a wid-er-angle lens in order to get the entire building into the picture while the camera is level. What happens, too, is that (if you're on ground level) more of the foreground than you want is in your picture. You can keep this blank patch from becoming an uninteresting grey area by, again, placing some object or person in the immediate foreground. Or, of course, you can just slice the bottom off the finished print.

Foreground objects in scenic pictures aid composition and add a feeling of depth. A well-placed foreground, by comparison, will indicate the distance between the pho-tographer and his subject.

Clouds also aid composition. You can emphasize them by darkening the skies in your black-and-white photographs with a

medium-yellow filter; or with a polarizing filter for your color. Color scenics also can be enhanced by the use of *skylight, haze,* or *ultraviolet* filters, which will remove the over-all bluishness found in most unfiltered outdoor landscape shots.

Two kinds of lighting seem to be preferable for outdoor landscape or architectural photography. A soft light will give your picture a modeled quality; a cross-light, coming when the sun is low and to one side, will emphasize texture and detail, while adding the extra dimension of long, strong shadow. A third, backlighting, has much to be said for it. The sun, behind the subject, will give it an outline of bright light, provided you expose for details in the shadow areas. If you take your exposure meter reading for the sunlight, in a backlighted scene, your foreground will become a silhouette.

Every photograph should have some main point, some one thing that is of more importance than everything else in the picture, and the rest of the picture should be organized around it. Its existence gives validity to the entire picture. Such an object exists in every scene worth photographing, and it's up to you to find and isolate it.

Make scenics more interesting by relating foreground and background elements to main subject. Use foreground objects as frames to add design and tighten composition. The subject itself can become a foreground or background element.

Sometimes you can improve a picture by simply waiting until it arranges itself. Learn to anticipate.

Even a simple camera can stop the action if you wait until the "peak"—the point when the action stops itself.

ACTION

Most beginning photographers prefer to stay away from taking pictures of objects in action, and yet of the four common methods of photographing action, three can be used with the simplest cameras.

The easiest way to photograph action, even with a box camera, is to position yourself so that the action is coming toward the camera. An object moving directly at you has much less apparent movement than one moving across your path or coming at you at an angle. Ordinarily, this head-on action can be stopped with a shutter speed of $1/50$ sec. which is the speed of most simple one-speed cameras.

One that's just as easy, but requires more practice, is shooting "peak" action. This is that brief moment in such action as jumping, diving, or swinging a baseball bat when the movement is suspended for an instant. In jumping, it's the top of the jump before the return to earth. In batting, it's that mo-ment at the end of the swing. In throwing, it's the final instant at the end of the follow-through. If you anticipate it and are ready for it, you can photograph peak action with the ease of photographing a non-moving object. Next time you see a pole vaulter or a diver, watch carefully, and you'll see the moment of suspended action at the peak. A slow shutter could capture it.

Practice is required for a third method, "panning," but this, too, can be accomplished with a one-speed shutter. Panning means moving with the action, and it's most successful when the subject is moving at a steady speed across the front of the camera. You center the subject in your viewfinder as it approaches. Then, keeping it in the viewfinder, you move your camera along with it. At one point you release the shutter, and in the finished picture you'll find that the subject is stopped, perfectly sharp, but the background will be blurred. This blur serves to illustrate the fact that the subject was moving.

Many professionals rely on the above-mentioned three methods, but quite often they fall back on fast shutters to "freeze" action that's moving in front of the camera. This is particularly true in sports photography, when the photographer must shoot the instant he sees his picture, without waiting for a peak of action or an opportunity to pan. If your camera has a selection of shutter speeds, you can take advantage of the faster speeds by using a fast film to reduce the necessary exposure time.

A fifth method for photographing action also is available to box camera owners and users of other cameras not featuring high shutter speeds. With this method you don't photograph the subject itself, but just the feeling or illusion of the action. To do so, you use whatever shutter speed your camera offers, allowing the moving subject to blur on the film.

One final point. The farther the subject is from the camera, the less apparent is the movement, and the less speed of shutter required to stop it photographically.

PEOPLE

Although people represent the most popular subject matter for the amateur photographer and the occasional snapshooter, whose greatest efforts are limited to irregular records of friends and relatives, it's in the photographing of people that most camera owners take the least trouble. This is attested to by the thousands upon thousands of snapshots printed every year, showing individuals or groups looking into the camera and smiling with various degrees of enthusiasm or embarrassment. It's almost as though the subjects feel that the camera can't see them if they can't see the camera, and that only a smile will insure a faithful record of what they look like. And with manufacturers making it ever easier to achieve technical quality in photography, it sometimes seems as though the frozen stare into the lens, combined with the fixed smile, is often the only thing that differentiates between good and bad amateur portraiture.

To set down a list of criteria for what makes a photograph of an individual a successful portrait is practically an impossibility, since the success of a portrait must, of course, lie in the eye of the beholder. If you were to judge a portrait of a stranger, you would judge it, mostly, for photographic quality, according to what you think a good photograph (and a good print therefrom) ought to look like. However, when you judge a portrait of a person you know, you try to see if the photographer has captured more than just the arrangement of his features; you look to see some indication, no matter how small or undefinable, of that person's personality as you know it. Almost everyone, when he examines a portrait of himself, expects it to show him as he thinks he looks.

All this constitutes a certain burden and responsibility for the man behind the camera. Which of the three judges, mentioned above, will he strive to please—the stranger, the friend, or the subject? He can eliminate the conflict by deciding to please none of these, and by shooting instead to satisfy himself—the artist, if you will. Then, he must decide for himself what the subject really looks like and how he would like him to appear on the finished print. He must decide which of the subject's expressions is most characteristic of him and seek to capture it on film. And then he must, by his wits, persuade the subject to discard his false pose and assume this natural expression before the camera. To do so requires more than a knowledge of photography. The problem was summed up by the eminent Swiss photographer Gotthard Schuh, who said, in part, "Our faces must be taken in surprise; we must be outwitted, in the manner of the huntsman stalking wild animals . . ."

In this *outwitting* lies the answer. One way to accomplish it is to take what would amount to a true *candid* portrait, in which the subject is unaware that his picture is being taken. The other way is to simulate candidness by using some psychology during the posing.

You have one advantage over your subjects. Only you know precisely when you're going to push the shutter release all the way down. Personally, I am for naturalness, in both professional portraits and snapshots of my family, and I choose to make full use of this advantage when shooting them. Anyone can do the same, regardless of whether he's using the least expensive box camera or the latest model Leica.

PORTRAITS OF ADULTS

The key to photographing adults is *confusion*. An adult will not fall for common distraction, so the photographer must create such a state of confusion in the mind of his subject that he loses his awareness of the potential action of the camera shutter. This confusion can be created in several ways, the commonest of which is to call attention to some fault in the formal pose the subject is working on. For instance, you

These Bedouins were never aware that they'd been photographed. I appeared to be looking through the viewfinder over their heads and then lowered the camera for the moment of exposure.

By waiting until someone else at the table caught her attention, I was able to eliminate this Geisha's efforts to pose frozen-faced.

might point out to the subject that his or her hair needs smoothing. The subject drops his guard for a moment and smoothes down his hair. During just such action you might get just the relaxed, and even pensive-looking, portrait you want. Tell a woman her lips need wetting, and during the instant just after the wetting, while she waits for your nod of approval, you're likely to find her wearing her most charming expression.

Many people refuse to relax their frozen poses while making the adjustments mentioned above, and you'll find it necessary to switch from constructive to negative criticism, which can't be followed with such simple gestures. When you say, "Your hair's a mess" or "Your tie is cockeyed," you're almost certain to produce the momentary relaxing of the corniest pose.

Your camera, of course, will be focused and ready.

There are several methods I use for breaking down the more stubborn hard-posers. One is to stare at a point just below the subject's chin or immediately above his brow line. A few seconds of this produces the uneasiness that leads to a breakdown of the pose. The most effective method, though, is to engage the subject in conversation. No one can maintain a formal pose for any length of time while carrying his end of a two-way conversation. Anyone, even if he has a vague awareness of the fact that he's being photographed, will drop his inhibitions after the first few minutes of informal conversation, and that's the time to start shooting.

Almost everyone has a pretty good idea of how he ought to pose to bring out the best in him. The photographer is burdened with the responsibility for maneuvering him out of it while maintaining a pleasant rapport with him. And if a bit of resentment should appear, it will be dissipated when your subject sees the finished prints, because portraits or snapshots taken during these tumbles into momentary relaxation are simply relaxed and give no indication of the devices you used to produce them.

CHILDREN AND BABIES

The key to photographing young people is *distraction.* Some of the most successful photographs of children are those taken when the subjects are engaged in activities other than posing for pictures, and are completely unaware of the presence of camera or photographer. But if you can't take candids, if the child knows you and the camera are there, ready to photograph him, he can be distracted for the length of time it takes to take a picture by some physical object. Forget the old habit of waving to a youngster from the camera and shouting, "Smile." Even when you succeed, the picture leaves much to be desired. With the help of a few simple things, usually found around the house, you can get really natural pictures of youngsters with little or no trouble.

There are four devices I have used with remarkable success.

Hand the youngster a bunch of cellophane tape. While he studiously works at removing it from his fingers you can catch plenty of good expressions. Have someone blow up a balloon. The child will, of course, watch it filling up with interest, and when it gets near the bursting point he'll be completely distracted, and you'll get your pictures. A device that is very successful in photographing very young children and babies is to have someone move a lighted candle about the room. There's something about the flickering flame that commands the attention of little children and keeps them occupied while you release the shutter. The fourth method calls for you to stand behind a television set while the youngster watches one of his favorite programs. He reacts to the action on the screen, be it cowboys or animated cartoon characters, and you, with your camera in operation, are completely ignored.

Children are easily distracted by each other. This portrait was taken by the light of a single living-room lamp.

GROUPS

The key to photographing groups of people is *focus.* This does not refer to the focus of your camera, but the focus of the attention of the group on one central point. This point of focus could be a member of the group, an object in the picture, an object outside the field of your viewfinder, or the camera and photographer.

To direct the focus of the group on a particular object, you ask a question about it. If, for instance, you want everyone to look in the direction of a fence post just off to the right, you ask, "What in the world is that on top of the fence post?" Assuming there is nothing there, the members of the group will have various reactions, quizzical, amused, and the like, but they'll all be directed in one direction.

To direct the focus of the group on one of its members, you don't say, "Now everybody look at John." They'll stare at him just as hard as they would have at the camera. Instead, you ask a question of John, but one that will require all the members of the group to turn toward him. You might try asking everyone to look at George; then, when they're all posing, frozen-faced, you might say something like, "John, what in the world are you doing with your hands?" They'll all turn toward him with natural expressions on their faces, and your photograph is made.

If you want something more casual, try throwing a ball into a group that's been standing around waiting for you to get your camera ready. Get your pictures during the scramble.

All the people in this group were too busy concentrating on what they were doing to be aware of what I was doing—taking their picture.

Sometimes you have to shoot first and ask questions later to get the most natural poses and situations.

16

DEVELOPING AND PRINTING

Many amateurs who have bought expensive professional cameras, who have studied them thoroughly and mastered them completely, continue to find a substantial area of difference between their pictures and those of the professionals. Often, this difference is merely a matter of *processing, i.e.,* developing and printing. While your films were developed and your negatives printed by mass production methods by an automatic machine, the professional developed and printed his own, or had the work done by one of the custom laboratories, where each roll of film is given individual treatment according to the customer's recommendations, and each print is made by hand, according to the customer's specifications. Although their services are relatively expensive, the custom labs are patronized by the professionals who find it well worth the money to have their processing given custom treatment. You may not find it worthwhile, since you don't get paid for each print, as the professional does; but you might well find it worthwhile to do your own processing, to give your pictures custom treatment in a home darkroom, and find, as well, that processing can be as exciting a part of your photography as snapping the shutter. In fact, there are some who claim that taking the pictures is only half of photography, with developing and printing filling in the balance.

It's true that in processing you do complete the job you started with the camera. With the camera you exposed the film to the action of light, but the result of that action remains invisible until the film is immersed in a chemical solution, a developer, that turns the exposed silver crystals on the film to black, and a fixing solution that prevents the light from having any further effect on the film, and in the bargain, dissolves all the unexposed grains of silver. The same treatment, a developing and fixing action, is given to the paper on which you make the print, and the result is similar, with the exception that the print is not transparent, since its emulsion is spread on paper instead of transparent plastic.

Why would anyone want to process his own pictures when he can have the work done quickly and inexpensively through his neighborhood camera or drug store? Doing your own processing gives you (here's that word again) *control.* You get control in developing your film; you can control grain, and believe it or not, film speed. The control of grain is accomplished by your selecting a developer of a formula designed (if it's fine grain you're after, or at least the finest grain possible with the film you're using) to give you the best results along these lines. The freedom to select a specific developer to complement a particular film is only part of the control you get when you do your own developing. You control, also, the time of development, and here you gain control over the film speed. To explain: For film exposed under normal (recommended) conditions, and according to the manufacturer's speed rating, you develop "normally." This should give you the best possible negative. However, suppose you want to manipulate the film's rating. Suppose your camera is loaded with a medium-speed film, but the lighting conditions under which you're about to shoot require a faster film. You can, if you plan to do your

Darkroom manipulation—darkening the foliage by "burning in" during enlargement—accentuates white geese and clouds.

and film development by manipulating the printing.) Cropping is the elimination of unwanted sections of the original negative from the finished print. In enlarging, you can, by increasing or decreasing the amount of projection, control the amount of the original negative that is projected onto your printing paper, within its size, and eliminate all else.

The controls we referred to in the previous paragraph fall into the category of advanced processing. To make the most of them you must first become thoroughly familiar with the basics, and then advance by instruction and experimentation.

Home processing does not require much space, since most of the equipment involved can be taken down and put away between sessions. Generally, the work is done in a bathroom or kitchen, but it can be done in any room that can be made dark enough, although running water is a great convenience.

Besides chemicals, all you need for developing film is a thermometer and a developing tank. Most tanks on the market today must be loaded in total darkness (a moment or two inside a closet or darkened room), but can be used in a lighted room after the film has been inserted. A roll-film tank contains a reel in which are two spiral sets of grooves, one on each half. The film is loaded into these grooves, and the reel is placed into the tank, which is then closed up. Chemicals can be poured in and out through a lightproof opening on top.

It is important to know the temperature of the chemicals. After determining this, the developer is poured into the tank, and left in for as long as is required for that particular developer at that particular temperature on that particular type of film. The developer then is poured off and a stop bath (just water, or a solution of acetic acid) is poured into and out of the tank. This is followed by the fixing solution; once the film has been fixed it may be exposed to light. Finally it is washed in running water and hung up to dry.

own processing, treat your medium-speed film as high-speed film. By *pushing* its speed you are, actually, *under*exposing it. But you can make up for this, within certain limitations, by *over*development. In printing, specifically in enlarging, you have contrast and cropping control. You can, by your selection of printing papers and developers, select from a variety of available contrasts in your finished print. (In addition, you can make up for failings in exposure

There are two types of printing, contact and enlarging. In contact printing the negative is held flat against the sheet of printing paper (in direct contact with the paper), and light is directed through the negative. Enlarging, also called projection printing, uses a projection principle. The negative is placed in a projector (called an enlarger), in which there is a light behind the negative and a lens between the negative and the paper. The negative image is then projected through the lens onto the printing surface. The greater the distance between the negative and the paper, the greater the degree of enlargement. An enlarger, like a camera, must be focused according to the distance between it and the paper. Once the paper has been exposed to light coming through the negative, it is placed into a tray of developer until the image on it becomes visible and developed to its optimum point. Then it is placed, briefly, into a stop bath, from which it goes into the fixing solution. Finally it is washed in running water and dried.

Although film must be developed in total darkness, paper is not sensitive to a certain brownish-yellow light, and such a light is used during the printing process. It is called a *safelight.*

Enlarger is actually a projector. Negative is placed above lens. Light beamed through negative projects negative image onto photographic paper held in easel on baseboard. Size of print is controlled by regulating distance between enlarger head and baseboard.

Basic equipment necessary for printing is:

A safelight, three trays, and a pair of tongs for handling the wet paper, plus

For contact printing: either a piece of heavy glass to hold the negative flat against the paper while the light, an ordinary room light, is on; or a print frame, which locks the paper and negative in a glass-covered frame; or a contact printer, which has its own light source under a glass surface, against which the paper and negative are held, and

For enlarging: an enlarger.

In addition, you might find a drying device a great convenience. Drying can be done between sheets of special blotter paper; in a blotter roll; on a sheet of shiny metal (called a ferrotype plate), onto which the paper is pressed flat, and which is held over some source of heat; or in an electric dryer, which is actually a ferrotype plate with its own heat source.

Negative is placed on contact printer; a sheet of printing paper is placed on top of negative; both are held together by pressure of specially constructed lid, while light from inside box exposes paper through negative.

17

NOW GET STARTED

The function of this book, as we explained, has been to introduce you to cameras and photography. You should be ready, now, to think about buying a camera and getting started taking pictures. Your first results may be disappointing, and if so, you should feel, rather than discouragement, that there is a good deal more to learn about your specific field of interest in photography, as well as your choice of cameras. You'll find there is a book for practically every area of photography, and a book for just about any individual camera.

Study every picture you take. Ask yourself, "What did I do wrong?" It won't be difficult to figure out, and when you recognize a mistake, you'll understand how to avoid making it again.

Try, also, to get variety in your pictures. The best way to do that is to carry a camera with you as frequently as possible; always, if you can get away with it. Shoot anything that interests you, but not indiscriminately.

Don't be satisfied with a single shot of any subject if there is more than one stage or angle to it. This means try for series of pictures—picture stories, as they're called in the magazines. If you make, or have made, enlargements, crop your pictures judiciously, and don't be reluctant to display them in mounts or frames, as well as in the good old family album.

If you take color, plan slide shows, but be sure to *plan* them, and only when you think the pictures are good enough to entertain an audience, not bore them.

Here are a few other tips that will help you enjoy photography.

Know your camera. Once you select and buy a camera, become familiar with all its features and controls. You may not need them all to take satisfactory pictures, but once you get to know them you'll find you'll be taking better pictures if you take advantage of everything the camera has to offer.

Keep it clean. Dirt, dust, and condensation are the photographer's greatest enemies. Your camera should be cleaned often with a camel's hair brush or a blower. Don't try to clean the lens with anything but these two items, plus, on infrequent occasions, a piece of soft lens-cleaning tissue, to remove fingerprints or condensation.

Handle film with care. Always load and unload your camera in subdued light, never direct sunlight, to avoid fogging the film. And keep the strip of opaque paper tightly wound around your film before and after you use it. Never store your film in a hot place, else the emulsion will melt. This goes, too, for a film-loaded camera.

Beware of camera movement. Keep your camera pressed against your face if it has an eye-level viewfinder, or against your body if it's waist-level. Squeeze the shutter release gently. Hold your breath when you release the shutter.

Don't double expose. Unless, that is, you want to for effect. Most of today's cameras feature some sort of double-exposure prevention. But to make sure you don't accidentally take two pictures on one section of the film, get into the habit of advancing the film immediately after taking a picture.

Watch that exposure. If your camera features adjustable shutter speeds and iris-diaphragm openings, check to see that these are set properly before you shoot. If you have a meter, use it. If not, pay close attention to the recommendations on the film instruction sheet.

Don't hesitate. If everything else is set, shoot as soon as the subject seems ready. Don't wait for an improved pose or action, or you might wind up with no picture at all. If things improve, you can always shoot another picture.

INDEX